DAT

EXPOSURE
CHRIS WESTON

AVA publishing SA
Switzerland

An AVA Book
Published by AVA Publishing SA
Rue des Fontenailles 16
Case Postale
1000 Lausanne 6
Switzerland
Tel: +41 786 005 109
Email: enquiries@avabooks.ch

Distributed by Thames & Hudson (ex-North America)
181a High Holborn
London WC1V 7QX
United Kingdom
Tel: +44 20 7845 5000
Fax: +44 20 7845 5055
Email: sales@thameshudson.co.uk
www.thamesandhudson.com

Distributed by Sterling Publishing Co., Inc.
in the USA
387 Park Avenue South
New York, NY 10016-8810
Tel: +1 212 532 7160
Fax: +1 212 213 2495
www.sterlingpub.com

in Canada
Sterling Publishing
c/o Canadian Manda Group
One Atlantic Avenue, Suite 105
Toronto, Ontario M6K 3E7

English Language Support Office
AVA Publishing (UK) Ltd.
Tel: +44 1903 204 455
Email: enquiries@avabooks.co.uk

ISBN 2-88479-098-5 and 978-2-88479-098-7

10 9 8 7 6 5 4 3 2 1

Production and separations by AVA Book Production Pte. Ltd., Singapore
Tel: +65 6334 8173
Fax: +65 6259 9830
Email: production@avabooks.com.sg

HOW TO GET THE MOST FROM THIS BOOK

This book introduces different aspects of photographic exposure via dedicated sections for each topic. The text offers a straightforward guide to the most frequently asked questions alongside photographic examples and technical diagrams.

Topics
The topics in each dedicated section are all listed on the subject introduction page.

Sections
This book is divided into nine sections, each one exploring a different aspect of exposure. The sections are identified by a different colour. The opening pages of each section clearly display the colour for that chapter.

Colour-coded tabs
Colour-coded tabs appear in the corner of each page to identify the section.

Clear navigation
Each of the 50 topics is numbered in the top corner of the page to make them easy to find.

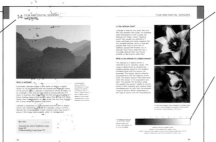

Visual explanations
Each question is illustrated using a series of photographic examples.

Diagrams
Additional technical information is provided and explained by the use of simple diagrams and icons.

Tip
The Shadow/Highlight tool is useful in extending the effective range of fill-in flash. Fill-in flash can't provide sufficient light to illuminate a dark or distant background without washing out the foreground subjects.

Tips
Look out for these panels, which offer handy tips on a variety of topics.

See also

Subject brightness range (page 83)
Understanding stops (page 72)

FAQs
A complete list of all the FAQs appears alongside the subject index.

See also
See also boxes cross-reference a topic to other related questions or topics that appear in the book.

Icon key
A simple reference guide to the symbols used within the diagrams.

 Camera

 Light source

 Grey card

 Flash

 Subject

 Filter

PHOTOGRAPHY FAQs

EXPOSURE

INTRODUCTION
6

UNDERSTANDING LIGHT
10
01 The direction of light
02 The quality of light
03 The colour of light
04 Digital White Balance
05 Tonality

TOOLS OF THE TRADE
20
06 TTL meters
07 Hand-held meters
08 Camera metering modes
09 Metering modes
10 Using grey cards
11 Understanding the EV chart
12 Calibrating a light meter
13 Histograms and the highlights screen

FILM AND DIGITAL SENSORS
36
14 Latitude
15 ISO and ISO-E
16 Grain and noise
17 Pushing and pulling film

TAKING A METER READING
46
18 Selecting a metering mode
19 Understanding your light meter
20 Exposure compensation and bracketing
21 Selecting an area to meter
22 What to meter if there's no mid-tone
23 The angle of incidence
24 Metering off-centre subjects
25 The simple zone system
26 Assessing the subject brightness range (SBR)

CONTROLLING EXPOSURE
70

27 Understanding f-stops
28 Shutter speed
29 Aperture and depth of field
30 The law of reciprocity
31 Faithful exposure

COPING WITH DIFFICULT LIGHTING CONDITIONS
82

32 Photographing in bright sunlight
33 Photographing white subjects in bright sunlight
34 Photographing snow
35 Silhouettes and backlighting
36 Night and low light
37 Macro and close-up

USING FILTERS
92

38 Filters and exposure
39 Neutral density (ND) filters
40 Polarising filters
41 Colour compensation (CC) filters
42 Filters for black and white
43 Exposure compensation for filters

FLASH EXPOSURE
102

44 TTL flash metering
45 Manual flash metering
46 Metering for bounced and diffused flash

THE DIGITAL DARKROOM
110

47 Using Levels and Curves
48 Selective exposure techniques
49 Enhancing depth of field and motion
50 Colour compensation

SUBJECT INDEX
138

ACKNOWLEDGEMENTS
140

EXPOSURE

FREQUENTLY ASKED QUESTIONS

UNDERSTANDING LIGHT

Why is the direction of light important? 12
What is meant by the term 'quality of light'? 13
How does the quality of light affect exposure? 13
What is meant by the term 'colour of light'? 14
Can you compensate for colour casts? 16
What is White Balance? 18
What is tonality? 19

TOOLS OF THE TRADE

What tools are available for measuring light? 22
What is a TTL meter? 22
What's the difference between a reflected light meter and an incident light meter? 23
If TTL meters are so accurate, why do I need a hand-held light meter? 24-5
What is a flash meter? 25
What's the difference between the three metering modes? 26-8
What's the difference between the exposure modes on my camera? 29
What is a grey card? 30
What is the relevance of the 18 percent grey value? 30
Can I use my hand as a grey card? 30
Why does my meter give me a number rather than exposure settings? 31
What is an exposure value (EV)? 31
How do I read an EV chart? 32
Do I need to calibrate my exposure meter? 33
How do I calibrate a meter? 33
What is a digital histogram? 34
What is the highlights screen? 34
How do I read a histogram? 35

FILM AND DIGITAL SENSORS

What is latitude? 38
Is film latitude fixed? 39
What is the latitude of a digital sensor? 39
What is an ISO rating? 40
Are digital ISO and film ISO the same thing? 41
What is the relevance of in-between ISO-E ratings? 41
What is the ideal ISO rating to use? 41
What is film grain? 42
What is digital noise? 43
How can I overcome digital noise? 44
Can film grain be used for artistic effect? 44
What is 'pushing' film? 45
How do I push a film? 45
By how many stops can a film be pushed? 45
What does 'pulling' film mean? 45
What are the pros and cons of pushing and pulling film? 45

FREQUENTLY ASKED QUESTIONS

TAKING A METER READING
When should I use multi-segment metering mode? 48
So, when is centre-weighted metering a better option? 49
When should I use spot-metering mode? 50-1
When I photograph bright colours or very dark colours the picture always seems under- or overexposed. Why? 52
How do light meters work? 53
Where does the 18 percent grey standard come from? 54
How does colour affect the meter reading? 54
How do I stop non-mid-tones from fooling the light meter? 55
How do I know how much exposure compensation to apply? 55
What is bracketing? 56
Why not bracket every shot? 56
What is auto bracketing? 56
Is there any point in bracketing in digital photography? 56
How do I select the right area to meter? 57
Why does the metered subject need to be in the same light as the actual subject? 57
What happens if there is no mid-tone subject to meter? 58
What is the angle of incidence? 59
How do I meter for subjects off-centre? 60-1
Can the simple zone system be used with 35mm and digital cameras? 63
How do I apply the simple zone system in the field? 64
Does the simple zone system work with automatic metering? 65
How can I master the simple zone system? 65
What is the Subject Brightness Range? 66
How do I measure the SBR of a scene? 67
Can I calculate SBR using the simple zone system? 67
How do I expose for a scene where the SBR is greater than the latitude of the film or digital sensor? 68
What if these options aren't possible or they are ineffective? 68

CONTROLLING EXPOSURE
What is a stop? 72
How do the shutter speeds displayed on my camera relate to the actual duration of exposures? 74
How does shutter speed affect the photograph? 75
Why do small-value numbers represent large apertures? 77
Why does my camera indicate apertures such as f/7.1 and f/13? 77
What is the visual effect of altering lens aperture? 77
What does the term 'stopping down' refer to? 77
What is the law of reciprocity? 78
When does the law of reciprocity failure apply? 78
How does the law of reciprocity affect digital cameras? 80
Can I use the ISO setting to control exposure? 80
Are there occasions when under- or overexposure is acceptable? 81

FREQUENTLY ASKED QUESTIONS

COPING WITH DIFFICULT LIGHTING CONDITIONS

What is the sunny f/16 rule? 84
What if I don't want to use f/16 as my aperture? 85
Does the sunny f/16 rule work with white subjects? 85
How can I meter for snow? 86
How do I expose for silhouettes? 87
How do I create a rim of light around a subject? 88
How do I meter at night and in low light? 89
How do I meter for macro photography? 90-1

USING FILTERS

Do I need to adjust exposure settings when using filters? 94
Do all filters affect the level of light entering the lens? 94
How does a neutral density (ND) filter work? 95
Why do I need a ND filter? 95
What effect on metering does a ND filter have? 96
What do the numbers used for ND filters mean? 96
What is a NDG filter? 96
How do I calculate exposure when using a NDG filter? 97
What is a polarising filter? 98
How much exposure compensation must be applied when using polarising filters? 98
How can I meter with the polariser in place when using a hand-held meter? 98
What's the difference between linear and circular polarising filters? 98
What's a CC filter? 99
Do CC filters affect exposure? 99
Why do I need a colour filter for black-and-white photography? 100
What are the exposure compensation values for commonly used filters? 101

FLASH EXPOSURE

How accurate are current TTL flash metering systems? 104
How do I know how much flash exposure compensation to apply? 105
What is a Guide Number (GN)? 105
How do I calculate the Guide Number (GN) for different ISO ratings? 105
How do I calculate the correct flash-to-subject distance? 106
What happens if the flash distance is fixed? 106
How do I get an even exposure that includes a well-lit background? 107
How can I calculate exposure when using bounced flash? 108
How do I expose for diffused flash? 109
Can I use a non-digital flash unit with a digital camera? 109

FREQUENTLY ASKED QUESTIONS

THE DIGITAL DARKROOM

What is a pixel? 112
What does the Levels tool do? 112
What are the elements of the Levels tool? 113
How do I use the Levels tool to increase contrast? 114-15
What is the Curves tool? 116
How can I correct shadow and highlight detail using Curves? 117
How can I control lightness and contrast using Curves? 117
Why use Curves and not the Lightness/Contrast tool? 117
Can I get more accurate results using Curves? 117
Is there a quick and simple method of dealing with underexposure? 118-19
How can I dodge and burn like the pros? 120-1
What is the Shadow/Highlight Tool? 122
What are the Highlight and Shadow sliders? 124
What other controls do the Highlight/Shadow sliders have? 125
How do I use the Highlight/Shadow tool to improve the exposure across
a photograph? 126-7
How do I modify the depth of field in this photograph? 128-31
What's the Motion Blur filter? 131
Can I digitally increase the depth of field? 132
How much Gaussian Blur should I apply? 132
How much Feathering should I apply? 132
Can you overdo depth of field modification? 132
Can I digitally apply colour casts? 134
How do I apply a Photo Filter? 135
Can I digitally emulate the effect of colour filters on black-and-white film? 136
Can I vary the 'filter effect' of splitting into separate channels? 137
Are Red, Green and Blue channels the only options? 137

INTRODUCTION

A question I often ask on my workshops is: how many people get their exposures right every time? In four years I've never known a delegate to put up their hand. In truth, the question is a little unfair, for who is to say when an exposure is 'right'? Certainly an exposure can be assessed technically to be right or wrong in a scientific sense, but photography isn't about science and technology, it is about artistry, and in an artistic world nothing is ever black and white, so to speak.

Truthfully, there is no such thing as correct exposure; what one photographer considers to be an exposure that accurately conveys the mood of a scene as he or she saw it, will be criticised by another because it fails to meet predefined, so-called technical rules. An obvious example of this conundrum is the silhouette. Technically, a silhouette is underexposed and yet who would question the power and graphic strength of such an image?

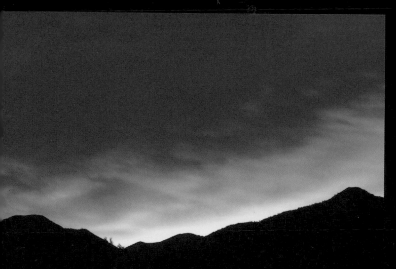

Silhouettes are a prime example of the fact that there is no such thing as correct exposure. Technically, a silhouetted subject is underexposed, but it is hard to argue against the power of their graphic statement.

So, if there is no such thing as correct exposure, what then is this book all about? When you make a photograph, unless it is for purely scientific purposes, you are creating a record of a moment in your life. For that image to be compelling to others, it must capture the mood and essence of the moment. In a single, small frame the photographer must bring to life what it was that compelled him or her to make the image in the first place. One of the inherent components of this task is to manage exposure in a way that helps in the telling of that story. In essence, what we are really trying to achieve is faithful exposure.

This is the purpose of Photography FAQs: Exposure. In the following chapters my aim is to open your mind and eye to the techniques and skills of managing exposure in order to produce results that are faithful to your artistic vision.

I talk about equipment because, like any skilled craftsman, knowing which is the right tool for the job in hand is as important as knowing how to use it. Light is, without question, the single, most important factor of photography, and I'll tell you how its fundamental qualities will affect your image-making abilities. I'll also tell you how to take a meter reading, rather than relying on the nuances of your camera, which, while no doubt highly accurate, has one fundamental flaw: it has no inkling of the picture in your mind's eye.

Beyond the basics, I'll look at how to control exposure to achieve the visual effects you want, how to create dynamism, energy and set the mood; how to include or exclude pictorial elements that define the emphasis and purpose of your photographs, how to cope with complex lighting, and, not least, how to use filters effectively and add flash to your arsenal.

When you make a photograph you are creating a record of a moment in your life. For that image to be compelling to others it must capture the essence and emotion of the moment.

Mastering the skill of managing exposure will enable you to faithfully reproduce on film or in print a scene as you saw it, physically, and, more importantly, emotionally.

For the digital converts amongst you, I even talk about how to manage exposure in-computer, using imaging software. For those of you who think this is a section for cheats, let me remind you that photography is, and has always been, a two-part process: what happens in-camera and what happens in the darkroom (whether wet or digital). There is no greater exponent of this fact than the great Ansel Adams who once commented, 'the negative is the score, the print is the performance.'

You will already have noticed that I talk quite a lot. Sorry, but it's part of the job. From here, however, it's over to you. For this book will only be of any use if you are prepared to put in some effort. I am as guilty as any for wanting a magic wand to master the necessary techniques of my profession. However, exposure – indeed, photography in general – is a skill, and like all skills it needs to be practised. Think for a moment, how many times did you need to drive a car before you became proficient enough to sit your driving test? Or, how many champion golfers do you know who earned their success without daily visits to the driving range?

look at them. When you see an image that truly speaks to you, analyse how you made it. And don't be hasty in discarding the rest, analyse them, too. Thomas Edison was once asked about the thousands of times his prototype light bulb failed, and if he ever thought of giving up, 'it's not that I failed a thousand times,' he replied, 'I simply found a thousand ways it didn't work.'

In that sentence, there is a lesson for us all. So I urge you again to go and take pictures. Oh, and take this book with you. You'll find it contains many hints, tips and techniques that will help you along the way.

What's the difference between knowledge and wisdom? Knowledge is what you know, but wisdom is taking what you know and applying it to its greatest effect. Cameras have knowledge built into their computers, but only photographers have the wisdom to use it effectively.

UNDERSTANDING LIGHT

It would be difficult, if not impossible, to write a book about exposure without reference to light. Exposure is the skill of managing light, so in order to master one you must master both. However, this is not a book devoted to light and lighting, so the following section is meant only as an introduction to light as it pertains to photography and exposure in particular.

01 **THE DIRECTION OF LIGHT** 12
02 **THE QUALITY OF LIGHT** 13
03 **THE COLOUR OF LIGHT** 14
04 **DIGITAL WHITE BALANCE** 18
05 **TONALITY** 19

Light is the fundamental tool of photography. In order to master exposure you must also become proficient in understanding the nuances of light.

Front lighting, which removes visible shadows, is ideal for revealing the detail in subjects such as buildings, but will also create a flat, two-dimensional form.

Why is the direction of light important?

Light falling from the side creates contrast between areas of highlight and shadow, giving photographs greater depth and a three-dimensional form.

The direction of light affects how the image appears in two-dimensional form. Frontal lighting, for example, removes visible shadows creating flat, formless images. Lighting from the side, on the other hand, makes shadow (and contrast) more visible, which will create photographs with more apparent dimensional qualities. Backlighting can be used to create silhouettes (see page 87) or rim-lighting effects (see page 88).

Quality of light refers to its intensity. High-intensity lighting, such as direct sunlight or spotlighting, is harsh, which creates well-defined shadows, as can be seen in this image of two skaters (right). Low-intensity lighting, such as diffused sun or flash light, has a softer quality, with less emphatic shadows.

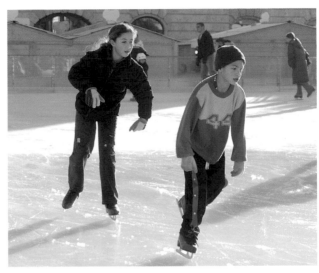

Here (below), the large umbrellas covering the market stall act as a diffuser, softening the harsh, direct light from the sun, thereby reducing contrast.

What is meant by the term 'quality of light'?

Light is often referred to in terms of its quality, which can be a misleading term. The quality of light refers to its harshness and is determined by its source. Light from a direct source, such as the sun or a spotlight, is deemed to have a hard quality, providing high levels of contrast and well-defined shadows. Diffused light, such as that seen on an overcast day when clouds scatter the light, or produced from a studio soft box, is deemed to be soft in quality, providing less contrast and more fuzzy shadows.

How does the quality of light affect exposure?

In terms of exposure, it is important to be aware of how the quality of light affects the level of contrast in a scene, as this will influence the subject brightness range (see page 84). The harder the quality of light, the more difficult exposure becomes when trying to manage latitude and retain detail throughout the scene.

13

The colour temperature of light

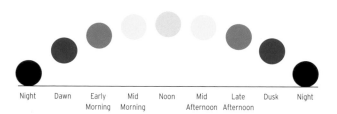

Night | Dawn | Early Morning | Mid Morning | Noon | Mid Afternoon | Late Afternoon | Dusk | Night

Light varies in temperature and colour, being warm and red in the morning and late afternoon to cool and blue during the daytime peak. We can only see white light, but cameras pick up the variances in light colour, which must be compensated for with filters or via the White Balance function on digital cameras.

What is meant by the term 'colour of light'?

Using your own eyes you'd never know it, but light ranges in colour depending on its source, the weather, the time of day and many other factors. The human eye is a sophisticated tool and automatically compensates for these changes in colour to the extent that we always see light as a neutral white. Photographic film, however, cannot do the same and is balanced for a single light colour, typically average daylight or tungsten light (digital sensors work differently, see page 18). The colour of light is determined by its temperature, which

is measured in degrees Kelvin (K). Daylight-balanced film is calibrated to produce neutral white light when the Kelvin temperature of light is around 5500 degrees. If the Kelvin temperature is any different then the film will produce a colour cast (of blue if the temperature is above 5500K and red if it is below 5500K) unless it is compensated for. The colour temperature of light produced from a household light bulb for example, is around 3000K, which will produce a noticeable orange cast to any images shot under it without compensation.

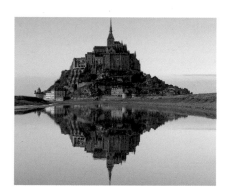

Warm, late afternoon light causes the stonework of the abbey and church of Mont St. Michel to glow. The colour temperature of light influences our emotional response to a scene.

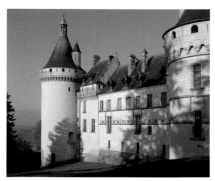

In comparison, this image of a French chateau was photographed closer to midday and has a much cooler overtone.

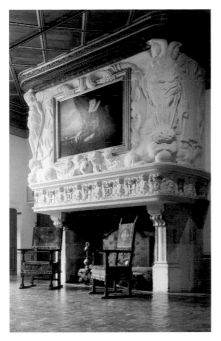 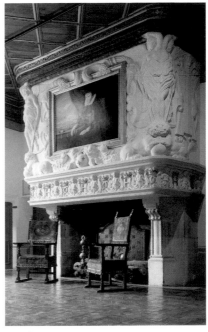

Different sources of light produce variations in colour temperature. For example, incandescent lighting has a very low Kelvin value compared to midday daylight, which can cause uncorrected images to appear orange (top right). By selecting an appropriate film (or, in this case, White Balance setting) or by using filters, you can remove this orange cast for a more natural-looking image (top left).

Tip

A simple way to remember colour temperature is to think in terms of heating a piece of metal. The metal starts out black or very dark grey. As it is warmed it turns red, then orange, followed by yellow, blue-white and white at its hottest.
The same thing happens to light. In the early morning, after dawn, it has a deep red quality, which changes during the day to a beautiful orange then yellow glow, before we get average daylight (blue-white). As the day progresses, after its peak, the colour temperature drops back eventually to the red glow of sunset before dark.

Can you compensate for colour casts?

Sometimes, colour casts can be pleasant, such as the beautiful warm glow of a sunrise or sunset. At other times, they can be distracting and detract from the aesthetic quality of the image. At these times you will need to apply colour compensation filters to remove the effects of colour temperature.

The table on the facing page identifies the recommended compensation filters for different light sources and colour temperatures when using daylight-balanced film. Please note that these are personal recommendations and not absolute rules.

For this image I used an 81-series filter to reduce the level of blue light, adding to the aesthetic quality of the image and giving it a warmer feel.

See also

Using filters (page 93)
Colour compensation (page 134)

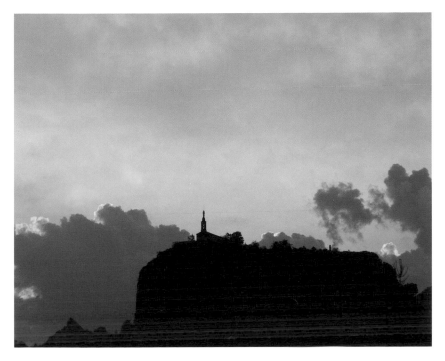

Conversely, for this image, I used no filter to
compensate for the beautiful warm glow of this
sunrise. To do so would have spoiled the effect.

Light source	Compensation filter
Clear blue sky	85B
Shade on a bright sunny day	81C
Overcast (cloudy) day	81B
Noon sunlight	81B
Average daylight	None (or 81A for a warmer appearance)
Dawn or dusk	None
Sunrise or sunset	None
Electronic flash	None
Fluorescent light	82C
Household light bulb (tungsten)	80A + 82C
Studio tungsten light	80A
Candlelight	None

What is White Balance?

Digital cameras have a White Balance (WB) setting. This control is used to compensate for any differences in colour temperature, and so allows the sensor to record light much as we see it with our own eyes. In effect, WB replaces the colour-correction filters used with film.

Some cameras have preset values for WB, such as cloudy, shade or tungsten. These settings can be applied to quickly reproduce a close-to-neutral, white light. More sophisticated digital cameras have a manual adjustment tool, allowing you to dial in a specific Kelvin temperature, which produces more accurate results.

Compare this set of three images. The first image (top) was taken at the camera's automatic White Balance setting, which has produced a neutral result. For the second image (middle) I set the WB to the cloudy setting, which has reduced the level of blue light and warmed the image. For the final image (bottom), I set the camera's WB setting to shade, which has significantly altered the mood of the image and produced a heavy orange cast. Of the three, I prefer the second image, using the cloudy WB setting.

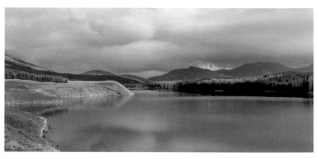

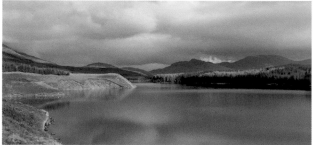

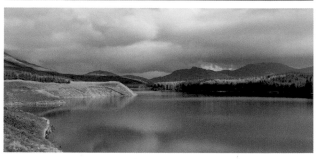

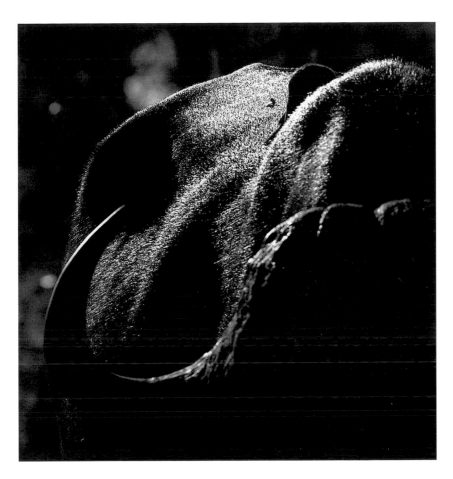

What is tonality?

The level of illumination can affect the tonality of the subject. For example, a black or very dark subject can appear white or silver depending on how the light falls on it, or a mid-tone leaf can be rendered much lighter when lit from behind. These nuances are important to note as a subject's tonality is rarely fixed and how you see your subject will be important when it comes to reproducing it as you want in a photograph.

The level of illumination can affect tonality. Here, for example, areas of this buffalo's skin appear light even though its natural colour is dark brown.

SECTION TWO

TOOLS OF THE TRADE

Few of us give more than passing consideration to the tools of exposure, taking for granted the technology built into modern-day cameras. However, there is more to calculating a faithful exposure than the through-the-lens (TTL) meter in your SLR. Knowing how the tools of exposure work will help you to understand their fallibilities and enable you to make appropriate compensations.

There is little doubt that modern exposure meters are highly accurate. They suffer, however, from one insurmountable flaw: they don't know what you are trying to visually achieve with your shot. That information resides only in your mind's eye, so it is vital that you are able to control the camera and how it exposes, rather than allow it to control you. To do this, you first must understand how the equipment you are using operates.

06 **TTL METERS** 22
07 **HAND-HELD METERS** 24
08 **CAMERA METERING MODES** 26
09 **METERING MODES** 29
10 **USING GREY CARDS** 30
11 **UNDERSTANDING THE EV CHART** 31
12 **CALIBRATING A LIGHT METER** 33
13 **HISTOGRAMS AND THE HIGHLIGHTS SCREEN** 34

For all their sophisticated technology, cameras suffer one key flaw: they have no idea what it is you are trying to artistically achieve. Mastering the tools of exposure is an essential element of the photographer's job.

What tools are available for measuring light?

Essentially, there are two tools available to the photographer for measuring ambient light. Many cameras today have a built-in reflected light meter, usually a TTL meter, although some models, typically rangefinder cameras, use a non-TTL system. The alternative to a built-in meter is a hand-held one that can measure reflected light, incident light or both.

See also

Understanding your light meter (page 52)

Hand-held light meters are available for those cameras without TTL-metering and useful for occasions when a greater level of control is needed.

What is a TTL meter?

A through-the-lens (TTL) meter is a built-in light meter that measures the level of light entering the lens. TTL meters are considered to be highly accurate because they give a reading of the light that actually reaches the film or sensor, taking into account any light-limiting accessories in use, such as filters or extension tubes. Typically, TTL meters are found only on SLR (single lens reflex) cameras and the technology they employ is highly sophisticated.

How TTL light meters work

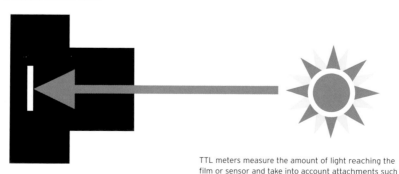

TTL meters measure the amount of light reaching the film or sensor and take into account attachments such as filters and extension tubes. This makes them highly accurate.

Incident and reflected light

There are two principal types of light meter: those that measure incident light and those that measure reflected light. Both have advantages and disadvantages that make them more appropriate to some situations than others.

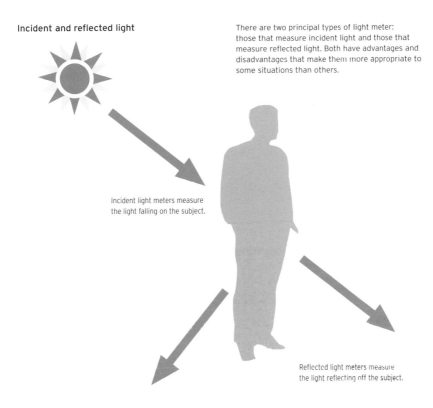

Incident light meters measure the light falling on the subject.

Reflected light meters measure the light reflecting off the subject.

What's the difference between a reflected light meter and an incident light meter?

Light meters work in one of two ways, either by measuring the amount of light falling onto the subject (incident light), or the amount of light reflecting off the subject (reflected light).

Incident light meters benefit from being uninfluenced by tonality and the light-absorbing properties of the subject. However, for greatest accuracy, the meter reading needs to be taken very close to the subject, which is not always possible (for example, with wildlife photography).

The main advantage of using a reflected light meter is that it measures the amount of light actually reaching the camera and, in the case of TTL meters, entering the lens. However, reflected light meters are affected by the tonality of the subject and are calibrated to give a mid-tone reading, irrespective of the tone of the subject.

23

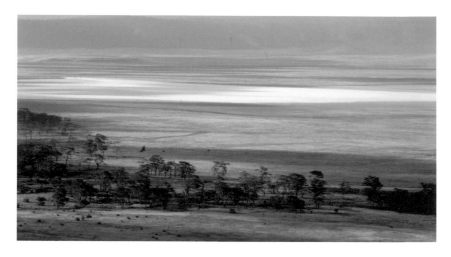

When photographing high-contrast scenes, such as this African landscape, a hand-held spot meter will provide a greater level of control over exposure than a built-in camera meter.

If TTL meters are so accurate, why do I need a hand-held light meter?

TTL meters have some limitations, including the precision of their spot metering facility, which is an inconvenience in some situations, and their inability to determine the tone of the subject being photographed.

Precision
Even the most sophisticated, professional-specification cameras have spot meters with a relatively wide angle of coverage, typically not less than three degrees, and often more. While that figure may sound narrow, for very precise applications, such as landscape photography, an angle of coverage as low as one degree, as provided by many hand-held light meters, is preferable.

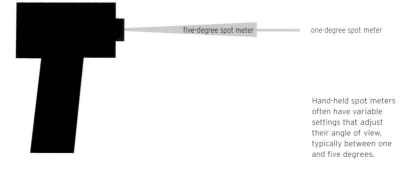

five-degree spot meter one-degree spot meter

Hand-held spot meters often have variable settings that adjust their angle of view, typically between one and five degrees.

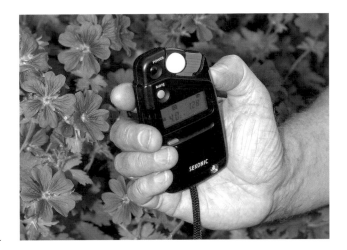

For greatest accuracy, a hand-held meter should be held close to the subject, pointing in the direction of the camera and in line with the lens.

Convenience

Imagine metering a scene that consists of several areas of varying tone. Ideally, you would assess the subject brightness range (SBR) of the scene and this would be far better achieved using a hand-held meter than your camera's built-in spot meter.

Tonality

Because a hand-held incident light meter measures the amount of light falling onto a subject rather than reflecting off it, the reading is unaffected by the tonality of that subject. So, when metering a scene that is predominantly much darker than or lighter than mid-tone, a hand-held incident meter is liable to produce more accurate results.

See also

Selecting a metering mode (page 48)
Assessing the subject brightness range (SBR) (page 66)

What is a flash meter?

As its name suggests, a flash meter is used to measure light levels when studio flash units are used as the main source of light.

What's the difference between the three metering modes?

Most in-camera meters have multiple exposure metering modes. Typically, these include multi-segment metering, average or centre-weighted metering and spot metering. Although, in older cameras only average or centre-weighted metering may be available. Each metering mode assesses light levels from a different area (or areas) of the picture space.

Multi-segment metering systems take several readings from different portions of the frame and provide an average value, often based on historic data held in a computer in the camera. For many subjects multi-segment metering is highly accurate.

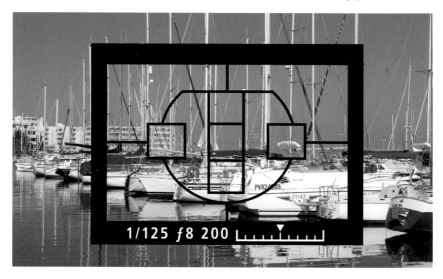

Multi-segment metering

Multi-segment metering is referred to by different names depending on the camera manufacturer. Nikon, for example, call their system Matrix metering, Konica Minolta's is called Honeycomb metering and Canon uses the term 'evaluative metering' to describe its system. In essence, however, they all operate in exactly the same way.

The picture space, as defined by the viewfinder, is divided into multiple segments and each one measures the amount of light relative to its part of the scene. The processor in the camera then assesses the SBR, assigns an exposure value and provides exposure setting information via the camera displays (and sets exposure settings in auto exposure or AE modes), which is based on an ideal exposure for the given SBR. Some cameras, such as the Nikon F6 and their D2-series digital cameras, use an additional function consisting of a database of reference images, which helps calculate the correct exposure value. It is arguably the most accurate means of determining exposure, but it is not without fault. You can achieve the same thing manually by taking several spot meter readings of the scene.

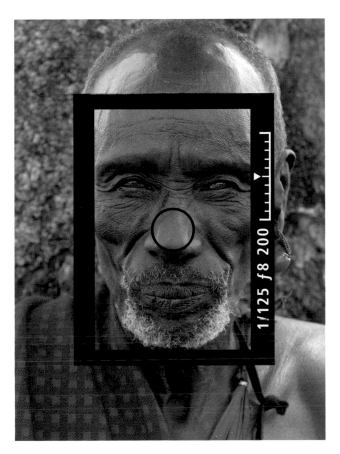

Average, or centre-weighted, metering systems place greater emphasis on the light falling in the centre of the frame, but don't discount background light. These systems are ideal for portrait shots.

Average or centre-weighted metering

Average or centre-weighted metering is the original form of in-camera metering. It operates by weighting the light reading for the centre portion of the picture space (usually around 75 percent) and the remainder for the area outside of this central portion (hence the term centre weighted).

This metering mode works on the theory that the subject is usually central to the picture space. In some ways this makes it an ideal form of metering, particularly for applications such as portrait photography. However, for more diverse subjects, such as landscape photography, it is less useful.

Some cameras, such as the Nikon F5 and F6 and their D2-series digital cameras allow you to adjust the size of the centre circle from which the camera takes the weighted light reading.

Spot metering

Spot metering gives the photographer the greatest level of control over the light reading. In-camera spot meters typically use a sensor that measures light from a very selective portion of the picture space, usually between three and five degrees. Hand-held spot meters are more accurate, with an angle of measurement often as narrow as one degree.

Spot meters enable the photographer to assess brightness values of highly distinct portions of the scene and are particularly useful when the scene includes several areas of varying brightness levels, such as landscape photography for example.

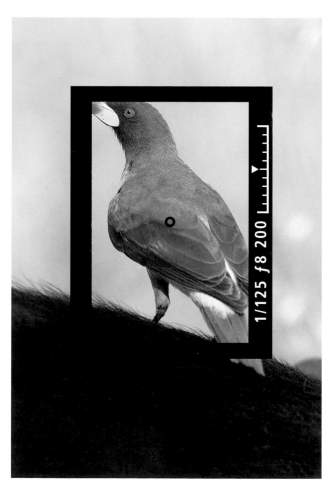

Spot-metering systems enable you to select very small areas of a scene from which to meter. Here I used a spot meter to take a reading from the bird's feathers.

What's the difference between the exposure modes on my camera?

Automatic cameras have several exposure modes, each one offering a different level of control. Typically the modes available are: programmed auto, shutter-priority auto, aperture-priority auto and manual.

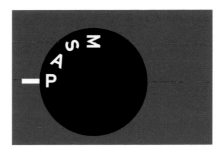

Control dial showing camera set to the programmed-auto exposure mode.

P - Programmed auto
A - Aperture-priority auto
S - Shutter-priority auto
M - Manual

Programmed auto

In programmed-auto mode the camera sets both the aperture and the shutter speed, which means that it controls the entire exposure equation. While this mode is useful for snapshot photography, it greatly limits artistic interpretation.

A variation of programmed-auto mode that is available on some cameras (usually entry level SLRs) allows the user to select the type of scene they are photographing, for example sports, portraits or landscape. This small piece of information tells the camera whether to give priority to shutter speed (as is the case for sport subjects) or aperture (as is the case for landscape subjects) and increases the user's level of control.

Shutter-priority auto

In shutter-priority auto mode the user manually sets the shutter speed and the camera sets the aperture. This exposure mode gives the user control over the appearance of motion (see page 74).

Aperture-priority auto

Conversely, in aperture-priority auto mode the user manually sets the lens aperture and the camera sets the shutter speed. This mode gives the user control over depth of field (see page 76).

Both shutter-priority and aperture-priority auto settings give the user a fair degree of control over exposure while benefiting from the advantages of AE metering.

Manual mode

For complete control over the exposure settings most cameras offer a manual override. Here the user selects both the shutter speed and the lens aperture, often in conjunction with a reading from a light meter.

What is a grey card?

All photographic light meters are calibrated to give a light meter reading for a subject that is mid-tone; otherwise known as 18 percent grey. A grey card can be used as a reference for assessing the tonality of the subject being photographed or, when placed in the same light as the subject, as an object from which to gain an accurate mid-tone meter reading, which can then be used to calculate an appropriate exposure value (EV).

Using a grey card when metering

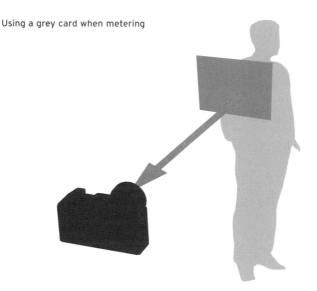

By placing the grey card in front of the subject, you can use it to assess a mid-tone. A grey card sometimes can be used to provide a mid-tone meter reading for a lighter or darker than mid-tone subject.

What is the relevance of the 18 percent grey value?

The value that the manufacturers of light meters use for calibration is set at 18 percent grey because it is the exact mid point of the camera film's ability to read detail in areas of both highlight and shadow.

See also

Understanding your light meter (page 52)

Can I use my hand as a grey card?

You may have heard advice about using your hand as a substitute for a grey card. The palm of a hand (it has to be the palm, because if you have a suntan the rule doesn't apply) is 1 stop brighter than mid-tone (18 percent) grey. Therefore, if you take a meter reading of your hand (as long as your hand is in the same light as your subject), and open the camera's meter reading by 1 stop you will have a mid-tone reading.

Why does my meter give me a number rather than exposure settings?

Some hand-held meters give a number rather than a combination of exposure settings. This number is called an exposure value (EV).

For this image I used an exposure of 1/30 sec at f/22. However, I could have used any combination of equal settings, such as 1/60 sec at f/16 or 1/15 sec at f/32. The level of light remains consistent based on the law of reciprocity.

What is an exposure value (EV)?

Every combination of lens aperture and shutter speed refers to an exposure value for a given ISO rating. The EV is a number that, when used in conjunction with an EV chart, produces appropriate combinations of useable shutter speeds and apertures. For example, an EV of 0 (zero) is equivalent to an exposure of 1 sec at f/1 for an ISO rating of 100. From this base, alternative settings can be calculated using the law of reciprocity, e.g. 2 sec at f/2, 4 sec at f/2.8, and so on. Each one-unit change in EV is equal to a 1-stop change in exposure.

See also

The law of reciprocity (page 78)

Exposure Value chart

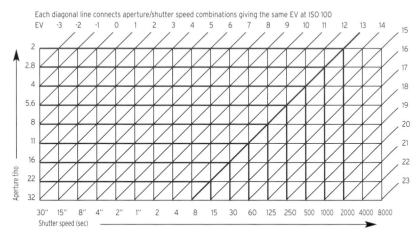

EV charts can be used to interpret exposure values, given by some meters in place of aperture/shutter speed combinations.

How do I read an EV chart?

EV charts can seem a little daunting at first sight, but they are fairly simple to interpret. The numbers along the top and right-hand side of the chart are the exposure values (EVs), in this example chart (above) ranging from –3 to 23. The numbers on the chart's left-hand side are values that relate to lens aperture, and along the bottom the numbers refer to shutter speeds.

To assess a lens aperture/shutter speed combination from any given EV, follow the diagonal line leading from the EV number, and at any point it crosses the intersection between the vertical and horizontal lines, read straight across for aperture and straight down for shutter speed. For example, EV 13 is equivalent to all the aperture and shutter speed combinations in this table (right), which are also indicated by the red lines marked on the example EV chart.

Lens aperture	Shutter speed (sec)
F/2	2000th
F/2.8	1000th
F/4	500th
F/5.6	250th
F/8	125th
F/11	60th
F/16	30th
F/22	15th
F/32	8th

Note that the stated EV is given in accordance with a specific ISO rating, usually ISO 100. If the actual ISO differs then you will need to make an adjustment. For example, if you are using an ISO 200 film then you would need to adjust the above settings by -1 stop.

Do I need to calibrate my exposure meter?

While all exposure meters are calibrated to give an exposure based on 18 percent grey, their manufacturing process necessarily includes some latitude that means the accuracy of your meter may be slightly out. Therefore, to ensure perfect accuracy, you should calibrate your meter and recalibrate it whenever you change film stock (including use of the same film-type taken from a different batch). Digital cameras should be calibrated before first use. In practice, going to such extremes really only applies for critical, professional applications.

How do I calibrate a meter?

Step 1
Place an 18 percent grey card in consistent light (outside on an overcast day is ideal).

Step 2
Attach your camera, with a standard (50mm) lens to a tripod and frame the grey card so that it fills the viewfinder.

Step 3
Focus on the grey card (you may need to focus manually to do this).

Step 4
Make sure the ISO setting in the camera is set to the same ISO rating as the film you are using. For digital cameras set an ISO equivalency of around 200.

Step 5
Set the metering mode to spot-metering and select the programmed-auto exposure mode on the camera. Take a picture, this is your base exposure.

Step 6
Using the exposure compensation function, and without moving the camera, take six further pictures at $+1/3$, $+2/3$, $+1$, -1, $-2/3$ and $-1/3$ stop. (If your camera has only $1/2$ stop increments take four further pictures between $+1$ and -1 stops in $1/2$ stop increments).

Step 7
After processing the images, review the results in comparison with the grey card. Whichever image most closely matches in tone determines the amount of compensation you should apply for a perfect mid-tone meter reading. For example, if the image taken at $+1/3$ stop matches the grey card then your meter's calibration is out by $+1/3$ stop.

What is a digital histogram?

The digital histogram is a graphic representation of the range and extent of tones in an image. Each vertical bar in a histogram graph represents the number of pixels that share a specified value between 0 (pure black) and 255 (pure white). A digital histogram is an indicator of tonal range and can help to identify under- and overexposure.

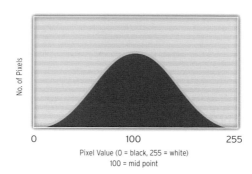

No. of Pixels

0 100 255

Pixel Value (0 = black, 255 = white)
100 = mid point

What is the highlights screen?

Most digital SLR cameras have a playback function known as the highlights screen. When an exposed image is played on the LCD monitor of the camera, flashing pixels identify those areas of the image where the level of brightness is too great for the camera to record detail. In effect, these pixels fall outside the dynamic range of the sensor. This is one of the most important and useful features on a digital SLR and can be used to ensure that highlights remain within range. Highlights are particularly important in digital photography, as any pixels beyond 255 (the value for pure white) are given no value, which makes it impossible to process those pixels. Effectively, they are discarded.

The highlights screen is arguably a more valuable in-camera tool than the histogram. With just a quick glance, it enables you to identify areas of the scene where the highlights fall outside the dynamic range of the digital photo sensor.

How do I read a histogram?

Look at the histograms on the right. The top two graphs show a (technically) well-exposed image. The graphs show the existence of tones in both the extremes (white and black) and an even spread of pixels throughout the grey scale. There are no pixels with a value outside the range of the histogram, indicating that detail exists in all areas of the photograph.

Now look at the third histogram. You can see that there is a high level of pixels whose value extends beyond 255 (pure white). In effect, these pixels have no value at all, indicating a loss of detail in the highlights, which is often referred to as washed-out highlights.

In the final histogram, the range of tones indicated is very narrow and there are no pixels at the black and white extremes of the graph. The narrow extent of this graph is indicative of a scene lacking in contrast, or form, which may result in a flat image.

In general, a histogram showing a graph that is skewed heavily to the right may indicate overexposure, while a histogram showing a graph skewed heavily to the left may indicate underexposure. The exceptions would be scenes that are deliberately under- or overexposed, for example silhouettes or low-key images (underexposure) and high-key images (overexposure). A histogram showing a narrow graph may indicate a lack of contrast, while a histogram showing a graph that is off the scale depicts an image where the level of contrast exceeds the latitude of the photographic sensor.

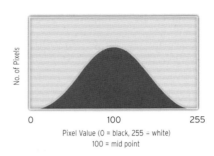

No. of Pixels

0 100 255

Pixel Value (0 = black, 255 = white)
100 = mid point

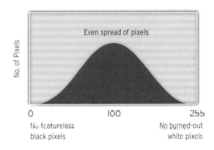

No. of Pixels

Even spread of pixels

0 100 255

No featureless
black pixels

No burned-out
white pixels

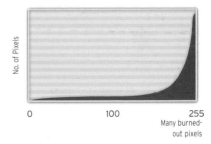

No. of Pixels

0 100 255

Many burned-
out pixels

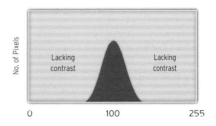

No. of Pixels

Lacking
contrast

Lacking
contrast

0 100 255

35

FILM AND DIGITAL SENSORS

Film or sensors (in a digital camera) are the components that record the light entering the camera. As such they are intrinsic to exposure. While there are many varieties of film and types of digital sensor they all share some important attributes, which are covered in the following section.

14 **LATITUDE** 38
15 **ISO AND ISO-E** 40
16 **GRAIN AND NOISE** 42
17 **PUSHING AND PULLING FILM** 45

Film and digital photo sensors are intrinsic to exposure.
Understanding how they work is essential to mastering
the skill of determining faithful exposures

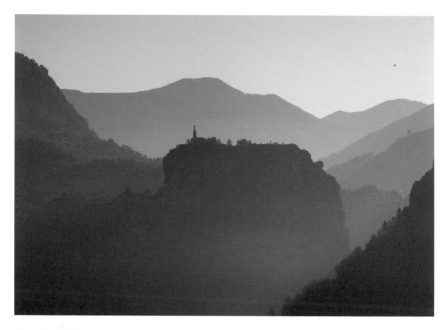

What is latitude?

Essentially, latitude relates to the ability of film or a digital sensor to record detail in both the shadow and highlight areas of the picture space. Latitude is measured in terms of stops, so for example, a film may be described as having latitude of 5 stops. In practice, this means that the film will record detail in those shadow areas of the picture space that are up to 5 stops darker than the highlights (or vice versa), but any tone beyond this 5-stop range will appear featureless.

Latitude is important in understanding how the film or digital sensor will respond to contrast. For example, using a narrow latitude film to photograph a high-contrast scene may result in areas of the image being greatly under- or overexposed.

In photographic terms, contrast is the difference in stops between the lightest and darkest areas of a scene. Latitude refers to film or digital sensor's ability to record detail simultaneously in both highlights and shadows.

See also

Assessing the subject brightness range (page 66)
Understanding f-stops (page 72)

Is film latitude fixed?

Latitude is fixed for any given film, but will vary between film types. For example, slide (transparency) film usually has latitude of 5 stops. Colour negative (print) film usually has latitude of 7 stops, and black-and-white negative film has variable latitude, which is typically greater than that of print film. In addition, certain film brands vary in latitude. Fuji's Velvia slide film has a narrower latitude than Fuji Provia; another of the brand's slide films.

What is the latitude of a digital sensor?

The latitude of a digital sensor is referred to as its 'dynamic range'. The range is determined by dividing the largest possible signal by the smallest possible signal that the sensor can generate. The largest signal is directly proportional to the full capacity of the pixel. The lowest signal is the noise level when the sensor is not exposed to any light. The greater the dynamic range the greater the sensor's ability to record detail in both highlight and shadow areas simultaneously. As with film, the dynamic range of sensors differs depending on the type of sensor and the manufacturer.

In both these images I have managed to maintain detail in areas of both highlight and shadow, working within the dynamic range (latitude) of the sensor.

The latitude of film and digital sensors varies between types and brands. This diagram can be used as a guide.

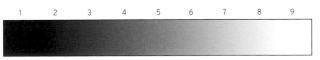

Latitude of slide film is usually 5 stops.
Latitude of colour negative film is usually 7 stops.
Latitude of black-and-white negative film varies, but is generally greater than print film.
Latitude of digital sensors will vary according to the dynamic range.

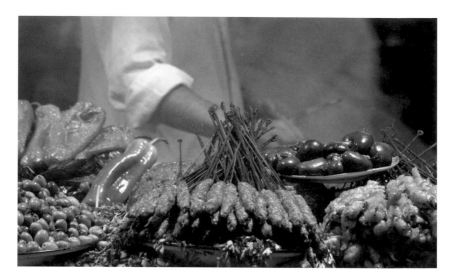

What is an ISO rating?

All films are given an ISO (International Standards Organization) rating, which is a standardised measurement of sensitivity to light. A low ISO rating, such as 50 or 100, denotes a low sensitivity to light, meaning that the film requires more light for a longer period in order to expose an image. A high ISO rating, such as 800 or 1600, represents a very sensitive film that requires less light for a shorter time in order for an image to form. Low-rated ISO films are often referred to as slow films, while higher ISO rated films are typically known as fast films.

Typically, ISO ratings increase in 1 stop increments (see page 72) and film is typically available with ISO values of 50, 100, 200, 400, 800, 1600 and 3200.

In low-light conditions a fast ISO/ISO-E rating will enable the film or sensor to react more quickly to light, enabling faster shutter speeds or narrower apertures to be used.

The slower the ISO rating of the film (or digital sensor) the more light that is needed to capture an exposure.

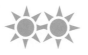

Reflected light

ISO 100 ISO 200 ISO 400 ISO 800

In bright conditions, when there is a high level of illumination, slow ISO/ISO-E ratings can be used, with flexibility of exposure settings still available.

Are digital ISO and film ISO the same thing?

Essentially, yes. The ISO setting on a digital camera is known as ISO equivalency (ISO-E) and works in exactly the same way as the ISO for film.

What is the relevance of in-between ISO-E ratings?

Just as many cameras allow adjustments in shutter speed or aperture in increments of 1/2 or 1/3 stop, some digital cameras allow you to alter the ISO-E in 1/2 or 1/3 stop increments too. For example, my Nikon D2X has ISO-E ratings of 100, 125, 160, 200, 250, 320, 400, 500, 640 and 800. Each increase in ISO-E value is equivalent to a 1/3 stop increase in sensitivity.

What is the ideal ISO rating to use?

There is no right or wrong answer to this question. It depends on a number of factors, including artistic interpretation and available light. What is important to know is that the higher the ISO rating of film the more film grain becomes visible, which can detract from print quality. In terms of digital photography, higher ISO-E ratings generate a greater level of digital noise that, similarly, can detract from the quality of the final image.

See also

Understanding f-stops (page 72)

What is film grain?

The light-sensitive element of film is made from tiny crystals of silver halide, which vary in size and shape. The higher the sensitivity of the film, the more apparent the crystals become. When the image is subsequently enlarged and printed, these crystals appear as dots on the image and this is what is referred to as film grain.

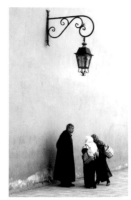

Film grain is apparent in all films, but more visible in fast films, such as ISO 800 and above. Typically, visible film grain detracts from image quality, although it can be used to artistic effect, particularly in black-and-white photography.

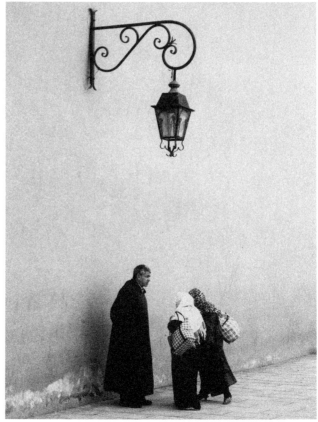

Digital noise is more apparent in areas of shadow. If you look closely at this image of a rose head you'll notice small spots of unrelated colour, caused by using a high ISO-E rating of 800.

Noise is a phenomenon of digital photography and is caused by the combination of sensor heat (typically during long exposures) and amplification (high ISO-E ratings). Digital noise manifests as random, unrelated pixels that degrade image quality.

What is digital noise?

Digital cameras increase the ISO-E rating by amplifying the signal recorded by the sensor. In essence, this process is the equivalent of turning up the volume on a television or hi-fi. By amplifying the signal, digital noise (artefacts or faults) is introduced, which appears in the form of random, unrelated pixels. For instance, in areas of dark shadow you may find coloured pixels of pink and green that bear no relation to surrounding pixels. The greater the level of amplification, the greater the occurrence of digital noise and the poorer image quality becomes.

Digital noise is also created during long exposure periods due to the heat generated by the sensor. Heat-generated noise usually occurs during exposures of longer periods than a half-second.

How can I overcome digital noise?

Because digital noise is generated by amplification and heat, photographing at low ISO-E ratings and keeping exposure times faster than a half-second will reduce the likelihood of it occurring.

For occasions when a high ISO-E rating and/or shutter speeds slower than a half-second are unavoidable, many digital cameras have a noise-reduction function that tells the camera to check for and eliminate noise during image-processing. This is a useful and effective function, but it can increase processing time, reducing burst depth.

Alternatively, there are several computer-based software solutions for overcoming digital noise.

Can film grain be used for artistic effect?

Although it is common to consider film grain as detracting from image quality there are occasions when it can be used to great artistic effect, particularly in black-and-white imaging. Certain subjects lend themselves better to a harsher, deeply textured appearance that changes the visual tone of the image, and, accordingly, our emotional response to the scene.

Film grain, either actual or simulated (in Photoshop) can be used to add an artistic interpretation to an image. In this shot, I have added simulated film grain to a sepia-toned picture of wildebeest to add to the atmosphere of the scene.

What is 'pushing' film?

Pushing (or up-rating) film is the process of exposing and processing a film at a higher ISO rating than that given by the manufacturer. For example, you might decide to push an ISO 100 film to ISO 200 in order to gain an additional 1 stop of sensitivity.

Pushing film is done typically when light levels are too low to allow an adequate exposure. By making the film more sensitive to light (by effectively increasing its ISO rating) you increase the range of exposure settings that can be used.

How do I push a film?

To rate a film at a different ISO rating than that given by the manufacturer you must first disable any automatic DX-coding system on your camera. This is the system that reads the bar code on the film canister and automatically sets the camera's ISO setting to the film's given speed. To disable DX-coding manually set the ISO rating on the camera.

The camera will now provide exposure information and, in AE mode, set exposures for the pushed ISO rating. When you remove the film from the camera, remember to mark the canister with an indication of the ISO rating used. When processing the film you must inform the lab that you have pushed the film (and how many stops by) in order for them to process it correctly. You can only push the whole strip of film, and not individual frames.

See also

Understanding EV charts (page 31)
Grain and noise (page 42)

When pushing or pulling film, always remember to clearly mark the canister to avoid confusion. The label will also be a reminder to the processing lab that the film has been re-rated.

By how many stops can a film be pushed?

It depends on the film but most films are best pushed by no more than 1 stop, in other words an ISO 100 film to ISO 200, an ISO 200 film to ISO 400, and so on. Some films react better to pushing than others and you should always refer to the manufacturer's guidelines.

What does 'pulling' film mean?

To pull a film is the opposite of pushing it. Effectively, you manually rate the film at a lower sensitivity than its given ISO rating, for example, rating an ISO 100 film at ISO 50.

What are the pros and cons of pushing and pulling film?

There are advantages and disadvantages to pushing and pulling film. Some films that are pushed to a higher sensitivity actually perform better than a film of an equivalent ISO rating. For example, when shooting film, I prefer to use Fuji Provia 100F rated at ISO 200 than any of Fuji's ISO 200 transparency films. The disadvantage is that not all films react well to the process, which can result in the degradation of image quality.

TAKING A METER READING

Given the level of sophistication inherent in modern cameras, you would be forgiven for thinking that it is the camera that takes a meter reading rather than the photographer. However, the camera only does what it is told to do, and where you point the camera, which exposure mode you select and how you interpret meter readings will affect how the final image is rendered.

The following section outlines many of the decisions you need to make when thinking about exposure and will help you to understand exactly what the camera's meter is telling you. By taking control of the exposure process you will notice that your images more closely resemble your expectations, and your ability to create consistently good photographs will improve.

18 **SELECTING A METERING MODE** 48
19 **UNDERSTANDING YOUR LIGHT METER** 52
20 **EXPOSURE COMPENSATION AND BRACKETING** 55
21 **SELECTING AN AREA TO METER** 57
22 **WHAT TO METER IF THERE'S NO MID-TONE** 58
23 **THE ANGLE OF INCIDENCE** 59
24 **METERING OFF-CENTRE SUBJECTS** 60
25 **THE SIMPLE ZONE SYSTEM** 62
26 **ASSESSING THE SUBJECT BRIGHTNESS RANGE (SBR)** 66

By taking control of the exposure process you will find that your images more closely resemble the photograph you pictured in your mind's eye.

When should I use multi-segment metering mode?

Multi-segment metering is arguably the most accurate form of auto exposure (AE) metering and is the most appropriate for general photographic applications. Indeed, I use this form of metering for around 60 percent of my work as a wildlife photographer. The way in which the multi-segment system operates makes it less susceptible to tonal variations, and increases its accuracy. However, this mode of metering also removes most of the photographer's metering control, relying instead on the camera to read the scene being photographed and to make decisions on which elements within the picture area are of visual importance. Therefore, while multi-segment metering is ideal for general application, for greater control over exposure, spot- or centre-weighted metering modes may provide a better solution.

Both of these scenes lend themselves to multi-segment metering. They have a wide range of tones all falling within the latitude of the sensor, given the weather, and the lighting was relatively even, making it easier for the camera to assess an accurate exposure.

So, when is centre-weighted metering a better option?

As the name implies, when the centre-weighted metering mode is selected the camera skews the light reading to the centre portion of the frame. This means that centre-weighted metering is ideal if the principal subject of the photograph is central to the image. An example of this would be in candid portrait photography, particularly outdoors.

In this image the subject fills a large portion of the frame and the background is secondary in the composition. However, because of the sitter's position, the level of light falling on the subject and background differs. Had I used multi-segment metering in this instance the likelihood is that the main subject would have been underexposed.

When photographing portraits, centre-weighted metering is a good option. The meter will assess the level of light in the centre of the frame (in other words, where the subject will usually be).

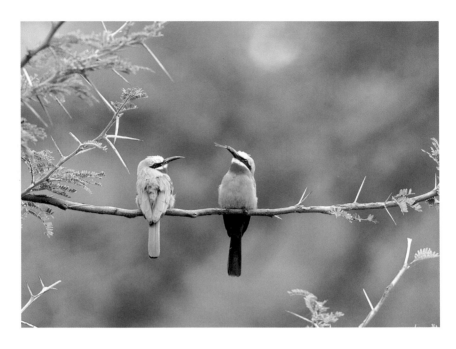

Spot metering provides the photographer with the greatest level of control over exposure, and can dramatically alter the visual presence of a scene. These African bee-eaters were first photographed using multi-segment metering, which produced an adequate result. I then switched to spot metering and took the same image (shown on the facing page, one of the birds had flown away by then), which produced a very different outcome.

When should I use spot-metering mode?

Spot-metering mode gives the photographer the greatest degree of control over exposure. In essence, spot metering allows you to manually do what multi-segment metering does automatically. The advantage of this mode is that you get the best of both worlds: the accuracy of multi-segment metering and retaining control over which subject or subjects within the scene need emphasising.

For this reason, the spot-metering mode is often used in outdoor photography, where scenes often vary in both tone and illumination. For example, compare these two images of African bee-eaters taken moments apart. In the first the camera is set to multi-segment metering and has produced a well-exposed photograph of the scene as I saw it. For the second image, I switched the exposure mode to spot metering and metered for the highlights in the background, which has created a silhouette of the subject, emphasising its presence in the picture and making what, for me, is a far more interesting image.

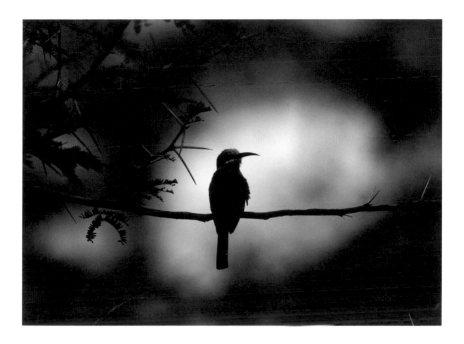

Essentially, the subject and how you want to portray it in relation to its surroundings should determine which metering mode you select. Multi-segment metering will tend to give an exposure balanced across the entire scene. Centre-weighted metering will help to emphasise subjects that fill a large portion of the frame. Spot metering gives the greatest level of control and allows you to select a very small area of the picture space to emphasise.

With this image, a spot meter was used to select the area around the man's face in the market. Here, the framing device and metering combine to graphic effect.

51

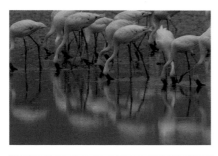
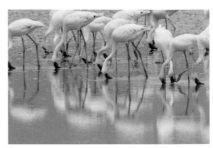
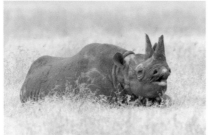
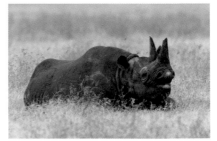

Without compensation an automatic exposure is likely to underexpose bright subjects, such as these flamingos (top row), and overexpose dark subjects, such as this black rhinoceros (bottom row). By applying the correct amount of exposure compensation, the camera will record the scene as it appears.

When I photograph bright colours or very dark colours the picture always seems under- or overexposed. Why?

All reflected light meters are designed to give a meter reading for a subject that is a mid-tone (or 18 percent grey). The camera does not know the colour of the subject you are photographing, so 18 percent grey is the line in the sand that camera manufacturers use to overcome the light-absorbing properties of different colours or tones.

In practice, this means that your camera's light meter (or a hand-held spot meter) will give a meter reading that will render the subject in a middle tone, irrespective of whether it is or isn't mid-toned. Snow, for example, when photographed at the camera's meter reading and without exposure compensation, will appear light grey (18 percent grey, to be exact). Similarly, a black horse will appear 18 percent grey under the same circumstances.

Light meters will always produce a result for a mid-tone subject. Therefore, their readings will underexpose light-coloured (or light-toned) subjects to make them darker and overexpose dark subjects (or dark tones) to make them lighter.

How do light meters work?

To understand how light meters work and the effects they have on photographing different tones, try this simple exercise.

On an overcast and dry day place three sheets of card on the ground; one white, one black and one medium-grey card. Set your camera's exposure mode to auto and the metering mode to either spot metering or centre-weighted metering. Take a picture of each sheet of card in turn, making sure that the card fills the viewfinder. Process the images and when you review them you will see that in each shot the sheet of card appears medium grey.

Now replicate the above steps but this time, when photographing the sheet of black card, underexpose from the camera's suggested exposure setting by 2 stops (apply -2 stops exposure compensation); and when photographing the sheet of white card overexpose by 2 stops (apply +2 stops exposure compensation). For the sheet of grey card, leave the exposure at the camera's recommended setting. When you process this set of images you will see that each shot has very distinct tones: one black, one white and one grey.

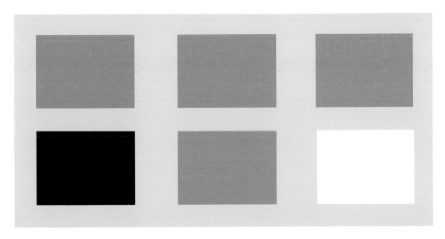

The set of images on the top row were all taken with the camera set to programmed automatic exposure. As you can see, they all appear virtually the same. When exposure compensation is applied, the resulting images reproduce the three sheets of card in their actual tones, one black, one grey and one white.

Where does the 18 percent grey standard come from?

Middle-tone or 18 percent grey is used as the standard for light meter calibration because it falls exactly halfway between film's ability to record pure white and pure black tones.

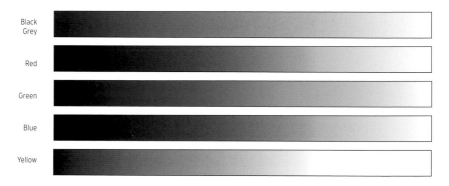

Black Grey

Red

Green

Blue

Yellow

The tone of a colour will influence the meter's reading. For example, blue can be mid-tone (such as blue sky at midday) or lighter than mid-tone (such as blue sky in the early morning). This colour chart illustrates how colours can range from very dark to very bright.

How does colour affect the meter reading?

What's important about colour, in the context of metering, is its tone. Think of colour in terms of the greyscale (see above diagram), which is how most light meters see colour. You will notice that some colours are medium-toned, some are lighter than medium tone and some darker. The light meter will treat each colour tone in terms of the greyscale, underexposing light colours and overexposing dark colours to give an exposure value for a medium tone.

See also

*Understanding your light meter
(page 52)*

How do I stop non-mid-tones from fooling the light meter?

If the subject being metered is lighter or darker than mid-tone then you must apply exposure compensation to combat the action the meter is taking.

Over- or underexpose by the right amounts to fool your light meter.

For lighter than mid-tone subjects the meter will underexpose to make the subject appear darker. To compensate you must do the opposite and overexpose from the stated meter reading. Conversely, for darker than mid-tone subjects, which the meter will overexpose to make light grey, you must underexpose from the stated meter reading.

Using this illustration you will be able to compensate for lighter- or darker-toned colours.

How do I know how much exposure compensation to apply?

After a while you will become experienced in assessing the tonality of subjects and learn by heart the required level of exposure compensation. In the meantime, the illustration shown here will help you to assess the tonality of different colours and provide a guide for the exposure compensation of each.

It is helpful to carry a grey card with you and use this as a reference for assessing the tonality of your subject. Hold the card up and compare its tone with the tone of your subject. Is the subject the same tone (mid-tone), brighter or darker? If the subject is brighter or darker, by how much is it so? A little or a lot? A little and 1 stop may be sufficient compensation. A lot and 2 stops might be more appropriate.

What is bracketing?

When it is impossible to determine the exact exposure for a subject, bracketing your shot may help. Bracketing involves taking two or more identical images at varying exposures. For example, you may take one shot of a scene at the camera's suggested exposure, followed by a second shot that is 1 stop overexposed from the camera's recommendations, followed by a third shot that is 1 stop underexposed. This will provide you with three identical images, each of which will be at slightly different exposures; from these three you can then determine which one is most accurate. You can make any number of bracketed images and increments need not be in whole stop adjustments. If your camera allows $1/2$ or $1/3$ stop increments then you might apply bracketing with these smaller incremental changes.

Why not bracket every shot?

There is an argument that by bracketing every image you'll always be sure of a faithful exposure. However, bracketing uses a lot of film – twice, three times, five times or more than when taking single exposures. Also, bracketing is not always practical, when photographing action sequences, of sport or wildlife, for example, where the scene is constantly and greatly changing from one shot to the next.

The original shot of this Ferris wheel (image A) was taken at dusk, a second shot of it was bracketed at 1/2 stop over (image B) and a third bracketed at 1/2 stop under (image C). Of the three shots, the original image (A) is underexposed and I prefer image (B).

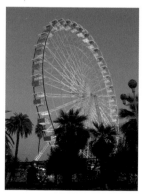

Image A: the original shot

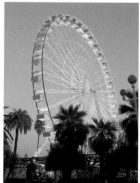

Image B: bracketed at $1/2$ stop over

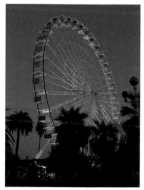

Image C: bracketed at $1/2$ stop under

What is auto bracketing?

Some cameras have an auto bracketing facility that, when set, instructs the camera to take a bracketed sequence of images, defined by the user, when the shutter is fired. It saves the photographer from having to manually adjust the AE settings when bracketing.

Is there any point in bracketing in digital photography?

Because digital photography enables immediate feedback of the exposed image the need for bracketing is less crucial. However, there may be occasions when it proves a useful technique, particularly if there is no time for reviewing and re-shooting the picture.

How do I select the right area to meter?

The easiest way to take a meter reading is to find an area of the scene that is mid-tone and in the same light as your subject. Metering from this area will give you a technically accurate exposure value.

For this picture, I knew from experience that had I metered the white door the camera would have underexposed the scene (to make the door a light grey, as it has been calibrated to do). Therefore, I metered from the surrounding brickwork, which I knew to be mid-toned, locked the exposure, recomposed the image and took the photograph. The resulting image is accurately exposed.

Why does the metered subject need to be in the same light as the actual subject?

If the mid-tone subject you are using for metering purposes is in shade and the actual subject to be photographed is in direct sunlight, for example, or vice versa, then the level of illumination will vary, requiring different exposures.

What happens if there is no mid-tone subject to meter?

This scenario is always possible. If there is no mid-tone subject in the same light as the subject to be photographed, then you can take a meter reading from the subject and apply a level of exposure compensation depending on the subject's tonality.

For example, say you are photographing an outdoor portrait of a girl in a yellow dress. Take a meter reading from the dress and apply +1.5 stops exposure to compensate for the lighter than mid-tone colour of the dress (see the table on page 79).

In this image there is no apparent mid-tone subject. I actually took a meter reading of the wall and opened the exposure by +2 stops using the exposure compensation function of the camera. Metering for the highlights and applying plus exposure compensation made it work, and the result is a well-exposed image that resembles the scene as I saw it.

Tip

When no mid-tone subject is available from which to meter it may be possible to use your grey card instead. Place the grey card in a position where it's in the same light as the subject and meter from the card. Of course, with some subjects, such as wildlife, this may be impossible!

What is the angle of incidence?

The angle of incidence is the angle between the light source and the subject in relation to the position of the camera. The angle of incidence will influence the tone of your subject and, therefore, your meter reading of it.

The brightness of a surface will alter depending on the direction from which it is viewed and the position of the light source. For example, a grey card facing the camera at an angle to the sun will appear mid-tone. Face the card away from the camera and towards the sun and it will appear brighter than mid-tone. Angle the card away from both the camera and the sun and it will appear darker than mid-tone. Therefore, to maintain an accurate meter reading it is important that the line of sight between the light meter (whether hand-held or in-camera) and the subject is kept perpendicular.

Of course, when using an in-camera TTL meter, the line of sight will nearly always be perpendicular. However, greater care must be taken when using a hand-held reflected light meter, to ensure that it is kept in line with the line of sight.

The angle of incidence

Brighter, subject in full sunlight

Average, subject in partial shade

Darker, subject in full shade

59

How do I meter for subjects off-centre?

The answer to this question depends on the metering mode selected. If you have set the metering mode to multi-segment metering then you should meter in the usual way (see page 48). However, if you have selected either centre-weighted or spot metering then you will need to take some additional steps.

Off-centre centre-weighted metering

In this metering mode, weighting is given to the central portion of the frame. If the subject is off-centre then it is likely that the meter will give an inappropriate reading. To overcome this, frame the image with the subject positioned centrally and then take a meter reading. Using the exposure lock button (if your camera has one) lock the exposure and then reframe the scene for your preferred composition. Keeping the exposure locked, take the picture.

If your camera has no exposure lock button, switch the metering mode to manual metering, frame the image with the subject positioned centrally and then take a meter reading. Once done, reframe the scene as you want it and take the picture. Because the metering mode is set to manual the exposure won't automatically change as you re-compose the scene but instead will remain fixed at the original setting.

For this image of a side-lit statue I switched to centre-weighted metering mode. Having set the exposure, I then used exposure lock before recomposing the image in the frame.

Off-centre spot metering

If your camera has only one, centrally positioned sensor for spot metering then you can use the same technique as for centre-weighted metering to meter for off-centre subjects (see page 60). Some cameras have more than one spot-meter sensor, which can be selected depending on the position of your subject. If this is the case, select the sensor that is closest to the position of your subject and take a meter reading in the normal way. If none of the spot sensors fall over your subject then again refer to the technique for centre-weighted metering.

Tip

If you are unsure whether your camera has multiple spot sensors, look through the viewfinder. You will see the position of any spot sensors. To switch between multiple spot sensors, refer to your camera's user manual.

The red jacket worn by the photographer in this scene is a mid-tone. I set the metering mode to spot metering and metered from the jacket. I then locked the exposure using AE-Lock and recomposed the scene before taking the picture.

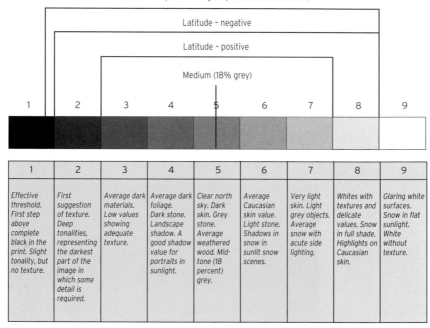

Latitude (Dynamic Range) - photo-sensor (variable)

Latitude - negative

Latitude - positive

Medium (18% grey)

1	2	3	4	5	6	7	8	9
Effective threshold. First step above complete black in the print. Slight tonality, but no texture.	First suggestion of texture. Deep tonalities, representing the darkest part of the image in which some detail is required.	Average dark materials. Low values showing adequate texture.	Average dark foliage. Dark stone. Landscape shadow. A good shadow value for portraits in sunlight.	Clear north sky. Dark skin. Grey stone. Average weathered wood. Mid-tone (18 percent) grey.	Average Caucasian skin value. Light stone. Shadows in snow in sunlit snow scenes.	Very light skin. Light grey objects. Average snow with acute side lighting.	Whites with textures and delicate values. Snow in full shade. Highlights on Caucasian skin.	Glaring white surfaces. Snow in flat sunlight. White without texture.

This table shows Ansel Adams's description for each of the nine zones and is a useful guide when assessing tonality in the field.

The formulation of the zone system is largely accredited to a great American landscape photographer, Ansel Adams. The principle of the system is the division of the greyscale into nine* equal segments, referred to as zones, starting with zone one (pure black) through to zone nine (pure white). The centre of each zone is exactly 1 stop brighter/darker than its neighbour and the centre of zone five is equivalent to mid-tone (18 percent) grey.

The full zone system is applied at all stages of the photographic (film) process: metering, exposure, development and printing. However, its simplified use can be applied when calculating accurate exposures.

*There is a more advanced zone system that uses eleven zones, particularly in large-format photography. Here, I shall refer to the more commonly used nine-segment system.

Can the simple zone system be used with 35mm and digital cameras?

You may read that the zone system is specific to large-format photography and can't be applied when using a 35mm or digital camera. Although the system was invented with large-format cameras in mind whether or not it can be applied when using medium- or small-format cameras depends largely on the type of meter used.

In essence, the zone system works at its optimum when used in conjunction with a narrow-view meter; typically a one degree spot meter. As some 35mm and digital cameras have no spot-meter facility and others have a limited (three degree) spot meter facility, the system can be used, but with limitations. In this event, the ideal would be to use a hand-held one degree spot meter.

Look at these two images and consider whereabouts in the zone system the main subject would fall. For example, the stone of the chateau (top right) fits the description given by Ansel Adams to zone six, whereas the darker stone of the walls behind the yellow car (above) are closer to the description given for zone four.

In order to make the water in this scene a darker blue than it actually was, I purposely exposed the scene to 'place' the water in zone four rather than zone five (mid-tone).

How do I apply the simple zone system in the field?

The beauty of the zone system is that it allows the photographer to decide how the scene appears in the final image, rather than letting the camera make the decision. For example, if you want a medium-toned, blue-coloured sky, which normally would be placed in zone five to appear as a lighter blue, then you can set your exposure for, say, zone seven, which is a lighter tone. Taking this example to its conclusion, you would meter for the medium-toned sky (for example, f/8 at 1/125 sec) and then apply +2 stops exposure compensation, since zone seven is two stops brighter than zone five, giving you an actual exposure of, say, f/8 at 1/30 sec.

The zone system can also be used to help identify the level of exposure compensation to apply to maintain true tonality when no mid-tone subjects are present from which to meter. For example, in this image of a flamingo I metered the feathers on the back of the flamingo as these were lighter than mid-tone. Applying the principles of the zone system, I 'placed' the feathers in the correct zone (five), which gave me an exposure compensation value of +1.5 stops. By overexposing, the true tonality of the subject is retained.

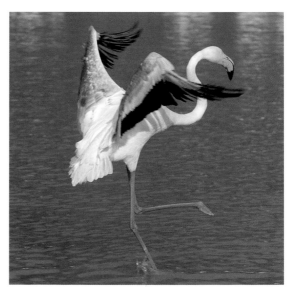

Does the simple zone system work with automatic metering?

As the purpose of the simple zone system is to allow the photographer to retain control of exposure, it works best when exposure is set manually. It is possible to adapt the use of AE metering in conjunction with exposure compensation, but to do so might prove more cumbersome than making use of the manual metering mode. Also, it is important to remember that the simple zone system is most effective when used in conjunction with a narrow-view (spot) meter.

How can I master the simple zone system?

Step 1
Learn how to use spot metering effectively.

Step 2
Select an appropriate area of the scene to meter. Shadow areas are best for negatives, areas of highlight are best for slides or digital.

Step 3
Decide what tone you want this area to resemble in the final image (and therefore in which zone to place it).

Step 4
Meter the chosen area of the scene.

Step 5
Adjust in stops the actual exposure by the difference between your chosen zone placement and zone five (the meter's calibrated zone).

Step 6
Practise, practise and practise some more. Carefully review your slides, negatives or digital files to see how your images are affected by your decision-making.

What is the Subject Brightness Range?

The subject brightness range (SBR) is the difference measured in stops between the darkest and brightest areas of a scene. It is important to exposure because photographic film and digital sensors have narrow latitude, and the extent of the range of tones will determine whether the film or sensor can retain detail in all areas of the scene or whether some areas fall outside the latitude. For example, slide film usually has latitude of 5 stops. If the SBR exceeds 5 stops then, without corrective action, detail will be lost in either the highlights or the shadows.

Another way to think of the SBR is contrast. A low SBR indicates a scene that is low in contrast, which may cause an image to appear flat when printed. A high SBR is indicative of high contrast, which will help to show form but may punctuate an image with burned-out highlights and featureless shadows.

To assess the subject brightness range (SBR), simply take a reading of the darkest and lightest areas of the scene. In this image the SBR is quite pronounced between the dark water and the light-coloured rock.

See also

Hand-held meters (page 24)
Latitude (page 38)
The simple zone system (page 62)

How do I measure the SBR of a scene?

To measure the SBR of a scene you will need a narrow-view meter, such as a hand-held one degree spot meter. Alternatively, the camera's built-in spot meter will suffice. Using the spot meter, take a reading for the brightest area of the scene and note it. Then, take a reading for the darkest area and note it. Once you have these two figures you can quickly calculate the difference between them.

If, for example, the brightest area of the scene is white snow in shadow and your meter reading is, say, 1/2000 sec at f/8 and the darkest area of the scene is dark grey mountain rock and the meter gives a reading of, say, 1/30 sec at f/8 then the difference (the SBR) is 6 stops. This figure is arrived at because:

1/2000 sec ◆ 1/1000 ◆ 1/500 ◆ 1/250 ◆ 1/125 ◆ 1/60 ◆ 1/30 = 6 stops

Can I calculate SBR using the simple zone system?

Yes. An alternative means of calculating SBR is to use the greyscale of the simple zone system. Place the darkest and lightest tones in the scene in their respective zones and calculate the difference in stops between zones.

For example, taking our hypothetical scene used in the example above, you might place the area of snow in shade in zone eight and the dark grey rock of the mountain in zone two. The difference between the two extremes is six zones, so again the SBR is 6 stops because:

8 ◆ 7 ◆ 6 ◆ 5 ◆ 4 ◆ 3 ◆ 2 = 6 stops

The SBR of this image can be calculated using the simple zone system.

How do I expose for a scene where the SBR is greater than the latitude of the film or digital sensor?

By determining the SBR you can easily deduce whether the scene's range of contrast falls within the latitude of the film or digital sensor. Where the SBR is greater than the latitude you have four options.

Firstly, you can reduce the level of illumination in the highlights (for example, reducing the power output of a studio flash or deflecting ambient light).

Secondly, you could increase the level of illumination in the shadows (for example, by adding fill-in flash or by using a reflector to direct light back onto the subject).

Thirdly you can change the light source, either from direct (contrast-rich) lighting to omni-directional lighting (for example, use a diffuser over a flash unit). Or, if outdoors, wait until conditions produce softer lighting (for example, overcast weather).

Finally you can use a graduated neutral density filter to block a portion of the light entering the lens (for example, to block light from a bright sky where the foreground is in shadow).

What if these options aren't possible or they are ineffective?

If none of the above is possible or the SBR remains greater than the latitude of the film or digital sensor then I'm afraid you must be prepared to lose detail in either the shadow area or the highlights. In general terms, it is better to retain detail in the highlights.

In this scene the range of tones between the sand and the sky exceeded the SBR. I compensated by using a graduated neutral density filter over the area of picture frame containing the sand, thereby evening the tones.

CONTROLLING EXPOSURE

How you apply exposure in relation to the camera will affect the visual interpretation of your scene. In practice, we control exposure using lens aperture and shutter speed, with lens aperture controlling the quantity of light reaching the film or digital sensor and shutter speed managing the length of time the film or sensor is exposed to light.

A favourite exposure analogy is to think in terms of filling a bucket of water. The bucket needs an exact amount of water in order to fill it, as film and digital sensors need an exact amount of light to record an image. To fill the bucket, you could pour a small stream of water for a long time or a large stream of water for a short time. Either way, the result is the same – a bucket full of water. In the context of exposure, the stream of water is analogous to the aperture and the length of time pouring is analogous to the shutter speed.

Technically, you can use many different combinations of stream size and pouring time to achieve the same result, just as you can use many variations of aperture and shutter speed to achieve an exact amount of light reaching the film or sensor.

27 **UNDERSTANDING F-STOPS** 72
28 **SHUTTER SPEED** 74
29 **APERTURE AND DEPTH OF FIELD** 76
30 **THE LAW OF RECIPROCITY** 78
31 **FAITHFUL EXPOSURE** 81

Left to its own devices a camera will produce adequate, but often uninspiring results. By taking control of exposure you can turn an ordinary scene into an artistic masterpiece.

What is a stop?

The key to controlling exposure is understanding the 'stop'.
In this context, a stop is a unit of measurement used in
photography that relates to light. Every incremental doubling
or halving of the quantity of light (aperture) or duration of
exposure (shutter speed) is represented as a 1-stop adjustment.
For example, if you increase the shutter speed from 1/125 sec
to 1/250 sec you are reducing by 1 stop (halving) the length of
time the shutter is open. If you increase the size of the lens
aperture from f/8 to f/5.6 you are increasing (doubling) the
quantity of light reaching the film by 1 stop.

The f/stop range of a typical lens

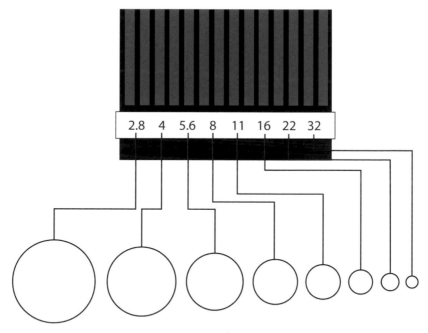

2.8 4 5.6 8 11 16 22 32

Lens aperture

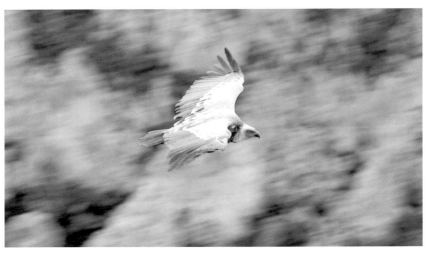

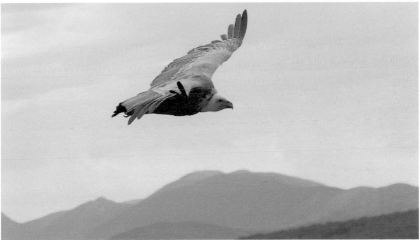

Although the location and subject of these images are identical the photographs are very different. One of the changes is the exposure. In the first image (top) I have used a slow shutter speed with camera panning to create a sense of motion and speed. In the second image (bottom) I have increased the shutter speed and the emphasis of the photograph switches to one of soaring grace.

28 | CONTROLLING EXPOSURE
SHUTTER SPEED

How do the shutter speeds displayed on my camera relate to the actual duration of exposures?

The numbers displayed by the camera for shutter speed denote seconds, or fractions of a second. If you look at the shutter speed settings on your camera you will note that they range from somewhere in the region of 30 sec to 1/2000 sec (although some cameras may go as fast as 1/8000 or 1/16000 sec). Look closely at this range of shutter speeds:

30 15 8 4 2 1 1/2 1/4 1/8 1/16 1/30 1/60 1/125 1/250 1/500 sec

from this scale you can see that each setting is practically half/double the length of time of its immediate neighbour.

A slow shutter speed combined with a moving subject can create a sense of speed and/or motion, as seen in this image of a cheetah.

74

King Township Public Library
Nobleton Branch

Customer ID: ********4539**
Messages
OK

Items that you have checked out

Title:
 Abroad at home : the 600 best international
 travel experiences in North America
ID: 32170030228376
Due: February-02-19
Messages:
Charged

Title: Exposure
ID: 32170021078707
Due: February-02-19
Messages:
Charged

Total items: 2
Account balance: $0.00
12/01/2019 2:57 PM
Checked out: 3
Overdue: 0
Hold requests: 0
Ready for collection: 0
Messages:

Items that you already have on loan

Title: A manual of modern palmistry
ID: 32170020314582
Due: February-02-19

Thank you for visiting Nobleton Public
Library

By selecting a slow shutter speed you can create visual blur that depicts motion (facing page). A fast shutter speed will freeze motion giving a very different visual effect (above).

How does shutter speed affect the photograph?

Shutter speed determines how motion appears in the final image. Simply put, a fast shutter speed will freeze motion, making it possible to decipher detail. Conversely, a slow shutter speed will blur the appearance of motion, producing a far more ethereal effect and adding a sense of visual energy and movement to the scene.

In this instance, the terms fast and slow are relative. For example, a racing car moves far quicker than a man on a bicycle. Therefore, a shutter speed fast enough to freeze the movement of the latter is likely to be too slow to do the same of the former.

Tip

It's a good idea to experiment with shutter speed and visualise its effect on composition. Position yourself along a stretch of straight road and photograph (at varying shutter speeds) the cars as they pass. Note the shutter speed used for each image and review the results to see how the image changes as shutter speed increases and decreases.

Lens aperture controls depth of field and determines subject emphasis. In this image a small aperture has made both the foreground and background appear sharp, emphasising the whole scene and creating a sense of depth. In the image on the facing page, a large aperture has caused the fore- and background bottles to blur, drawing attention to the centre of the scene.

F-stop numbers represent lens aperture. Look at your camera's lens (or its LCD panel) and you will see a scale that ranges typically from around f/2 to f/32 (some lenses may have more or fewer settings), usually in the following series:

f/2 f/2.8 f/4 f/5.6 f/8 f/11 f/16 f/22 f/32

F-stops are a ratio of the diameter of the aperture and the focal length of the lens. For example, on a 50mm lens f/2 represents an aperture with a diameter of 25mm, because:

$$\frac{50 \text{ (focal length)}}{25 \text{ (diameter)}} = 2$$

In itself, this doesn't explain the halving/doubling equation that's at work here. The reason f/8, for example, represents twice the quantity of light as f/11 and half the quantity of light as f/5.6 is due to the area of the aperture. For example, using a 50mm lens the area of the aperture at f/8 is 31 sq. mm. At f/11 it is 16 sq. mm and at f/5.6 it is 63 sq. mm. Tabulate these figures as I've done here (left), and you can see the clear link with the doubling/halving equation. As the table shows, 31 sq. mm is practically half the area of 63 sq. mm and practically double the area of 16 sq. mm.

Aperture	Area (sq. mm)
f/11	16
f/8	31
f/5.6	63

Why do small-value numbers represent large apertures?

On the face of it, this can appear confusing, but again it comes back to ratios. We have seen already that a 50mm lens with an aperture of 25mm has a ratio of 2:1 (or f/2). Now take the same 50mm lens with an aperture of 12.5mm and you get a ratio of 4:1 (or f/4). So, f/4 is smaller than f/2 because 12.5mm is smaller than 25mm.

For easy reference, think of aperture values (f/stops) in terms of fractions. For example, 1/16th (f/16) is smaller than 1/8th (f/8).

Why does my camera indicate apertures such as f/7.1 and f/13?

The f-stop numbers I have indicated thus far relate to whole stop shifts in aperture. Many modern cameras allow you to adjust f-stops (and shutter speeds) in 1/2- or 1/3-stop increments. So, f/7.1, for example, is 2/3 stop smaller than f/5.6.

What is the visual effect of altering lens aperture?

Lens aperture will determine the area of your scene that appears to be in sharp focus. This area is your depth of field. The larger the lens aperture the less depth of field and, conversely, the smaller the aperture the greater the depth of field. Depth of field controls the emphasis within an image. When the image appears sharp from the foreground through to infinity, emphasis is placed on space and a sense of place. However, when depth of field is narrow it helps to isolate the principal subject from its surroundings.

What does the term 'stopping down' refer to?

Typically, stopping down is used to describe the process of reducing the amount of light reaching the film or sensor by decreasing the size of the lens aperture. For instance, by changing the aperture from f/8 to f/11 you are stopping down by 1 stop.

The law of reciprocity

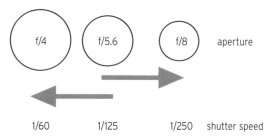

The law of reciprocity states that a change in one exposure setting must be accompanied by an equal and opposite change in another for parity to be maintained.

What is the law of reciprocity?

The law of reciprocity states that in order to retain parity, any change in one exposure setting must be compensated for by an equal and opposite change in the other. For example, if you halve the quantity of light reaching the film by narrowing the lens aperture from f/5.6 to f/11, then, in order to retain the same exposure you must double the length of time the film or sensor is exposed to light by reducing the shutter speed by 1 stop (e.g. from 1/250 sec to 1/125 sec).

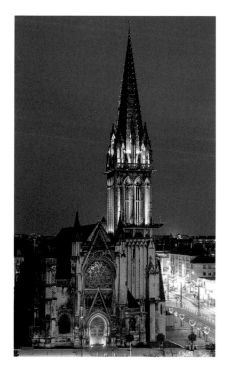

When does the law of reciprocity failure apply?

When using film, the law of reciprocity fails during long exposure times, typically those longer than one second, although it depends on the film. This is because film becomes less sensitive to light the longer it is exposed. The effect of law of reciprocity failure is that exposure compensation must be applied depending on the length of the exposure and the film used. For precise details, refer to the film manufacturer's guidelines.

See also

Night and low light (page 89)

When shutter speeds exceed one second the law of reciprocity fails. When photographing in low light, for example, you may need to increase exposures beyond the law of reciprocity to compensate.

Reciprocity characteristics of Kodak films

Film	Exposure adjustments/Correction filters					
	1/10,000	1/1,000 to 1/100	1/10	1	10	100
Professional Ektachrome E100S	None/no filter					+ 1/3 stop CC075Y at 120 sec
Professional Ektachrome E100SW						
Professional Ektachrome E100VS	None/no filter					NR
Professional Ektachrome E200						
Ektachrome 64 Professional (EPR)	None/no filter			+ 1/3 stop CC05R		NR
Ektachrome 100 Professional (EPN)	None/no filter			+ 1/3 stop CC05M		NR
Ektachrome 100 Plus Professional (EPP)	None/no filter			+ 1/3 stop CC025R	+ 1 stop CC025R	2 stops CC10Y + CC025R
Ektachrome 200 Professional (EPD)	None/no filter			+ 1/2 stop CC05M		NR
Ektachrome P1600 Professional (EPL)	None/no filter			Make tests for your actual conditions		
Kodachrome 64 (Daylight) (KR)	None/no filter		+ 1/3 stop CC05M			NR
Kodachrome 64 Professional (PKR)						
Kodachrome 200 (Daylight) (KL)	None/no filter			+ 1/2 stop CC10Y		NR
Kodachrome 200 Professional (PKL)						
Elite Chrome 100 (EB)	None/no filter					+ 1/3 stop CC075Y
Elite Chrome Extra Color 100 (EBX)	None/no filter					NR
Elite Chrome 200 (ED)						
Elite Chrome 400 (EL)	None/no filter			+ 1/3 stop or 1/2 stop CC05R	+ 1/2 stop CC10R	NR

If indicated exposure time is (seconds)	Adjustments for Long and Short Exposures					
	Kodak Professional T-MAX 100 film		Kodak Professional T-MAX 400 film		Kodak Professional T-MAX P3200 film	
	Use this lens-aperture adjustment OR	This adjusted exposure time (secs)	Use this lens-aperture adjustment OR	This adjusted exposure time (secs)	Use this lens-aperture adjustment OR	This adjusted exposure time (secs)
1/10,000	+ 1/3 stop	Change aperture	None	None	None	None
1/1,000 to 1/10	None	None	None	None	None	None
1	+ 1/3 stop	Change aperture	+ 1/3 stop	Change aperture	None	None
10	+ 1/2 stop	15	+ 1/2 stop	15	+ 1/2 stop	15
100	+ 1 stop	200	+ 1 1/2 stop	300	+ 2 stops	400

Reciprocity characteristics of Fujichrome films

Film	Shutter speed/Correction filters/Exposure adjustments				
Fujichrome Velvia for professionals (RVP)	1/4000 sec to 1 sec	4 sec.	16 sec.		64 sec. and longer
	None	5M + 1/3 stop	10M + 2/3 stop		Not recommended
Fujichrome Provia 100F Professional (RDPIII)	1/4000 sec to 128 sec	4 min.			8 min.
	None	2.5G + 1/3 stop			Not recommended
Fujichrome Astia 100 Professional (RAP)	1/4000 sec to 32 sec	64 sec.	2 min.		8 min.
	None	None + 1/3 stop	None + 1/2 stop		Not recommended
Fujichrome MS 100/1000 Professional (RMS)	1/4000 sec to 32 sec	64 sec.	2 min.		8 min.
	None	None + 1/3 stop	None + 1/2 stop		Not recommended
Fujichrome Provia 400F Professional (RHPIII)	1/4000 sec to 32 sec	64 sec.	2 min. to 4 min.		8 min.
	None	5M + 2/3 stop	7.5G + 1 stop		Not recommended
Fujichrome 64T Type II Professional (RTPII)	1/4000 sec to 1/30 sec	1/15 sec. to 64 sec	2 min.	4 min.	8 min.
	Not recommended	None	None + 1/3 stop	None + 1/3 stop	Not recommended
Fujichrome Sensia 100 (RA)	1/4000 sec to 16 sec	32 sec.	2 min.		8 min.
	None	None + 1/2 stop	2.5R + 1 stop		Not recommended
Fujichrome Sensia 200 (RM)	1/4000 sec to 32 sec	64 sec.	2 min. to 4 min.		8 min.
	None	5G + 2/3 stop	7.5R + 1 stop		Not recommended
Fujichrome Sensia 400 (RH)	1/4000 sec to 32 sec	64 sec.	2 min. to 4 min.		8 min.
	None	5G + 2/3 stop	7.5R + 1 stop		Not recommended

How does the law of reciprocity affect digital cameras?

The law of reciprocity affects digital cameras in the same way as it affects film; a change in one exposure setting must be compensated for by an equal and opposite change in the other. However, because digital sensors lose no sensitivity to light, irrespective of how long the duration of the exposure, they are unaffected by law of reciprocity failure.

Can I use the ISO setting to control exposure?

With film, using the ISO setting to control exposure is limiting as it applies to the entire roll of film. Digital cameras are more flexible allowing adjustment of ISO-E for each individual frame. Therefore, it is possible to apply the law of reciprocity using ISO-E in place of either lens aperture or shutter speed.

Adjusting ISO has no impact on the visual presence of the image other than how it affects the occurrence of film grain or digital noise.

Are there occasions when under- or overexposure is acceptable?

There is no such thing as 'correct' exposure. The essence of exposure is managing light to reproduce a scene exactly as you perceive it to be. In other words, what you are trying to achieve is faithful exposure. This might include underexposing areas of a scene for artistic intent. A prime example here would be to create a silhouette. High-key portraits (essentially overexposing whites) are a good example of using overexposure artistically.

See also

Silhouettes and backlighting
(page 87)

In this scene (below), I wanted to exclude distracting background detail inside the window frame to emphasise the man. I set an exposure that under-exposed the shadow areas to an extent that all detail is lost.

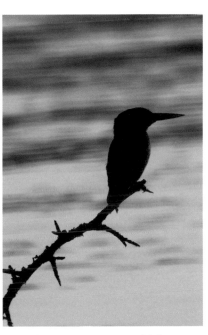

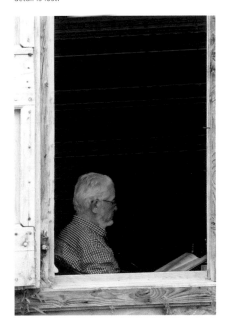

Over- and under-exposure are appropriate in some circumstances. When photographing this kingfisher (above), I underexposed the scene to create a silhouette.

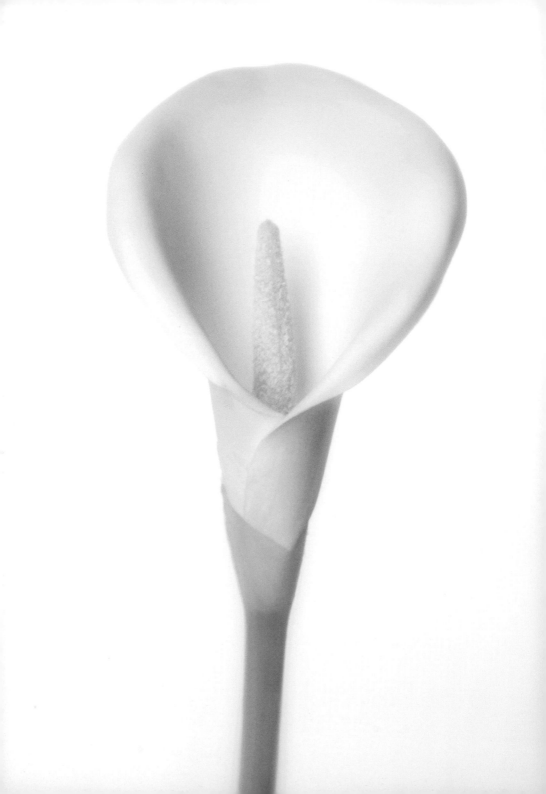

COPING WITH DIFFICULT LIGHTING CONDITIONS

Sometimes lighting conditions present the photographer with challenges that are difficult to master, however advanced their knowledge might be. These challenges are often a product of the camera's limitations. They are not insurmountable, but the photographer must know what he or she is doing and be able to control and manage the equipment in a practical way.

32 **PHOTOGRAPHING IN BRIGHT SUNLIGHT** 84

33 **PHOTOGRAPHING WHITE SUBJECTS IN BRIGHT SUNLIGHT** 85

34 **PHOTOGRAPHING SNOW** 86

35 **SILHOUETTES AND BACKLIGHTING** 87

36 **NIGHT AND LOW LIGHT** 89

37 **MACRO AND CLOSE-UP** 90

Subjects that sit at the edges of a camera's capabilities provide exposure challenges for the photographer that are difficult, but not impossible to master.

In bright sunlight you can use the simple, yet effective, sunny f/16 rule, as I did here when photographing this African elephant in the middle of the day.

What is the sunny f/16 rule?

On a sunny day, around noon when the sun is high in the sky, the levels of contrast caused by such bright conditions can be excessive and problematic to light meters. A simple and surprisingly effective alternative to using the camera's meter reading is to apply the sunny f/16 rule.

This rule requires you to set your aperture to f/16 and your shutter speed to a setting close to the ISO rating of your film (or the ISO-E in digital). For example, if using Fuji Provia 100F film, you would set an initial exposure of 1/100 at f/16 (or 1/125 at f/16 if your camera has only full 1-stop increments available).

The sunny f/16 rule

Set the lens aperture to f/16

Set the shutter speed to match the ISO rating (e.g. 1/100th sec)

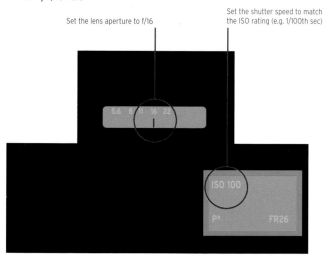

To use the sunny f/16 rule, set the camera's shutter speed to the closest equivalent of the ISO/ISO-E rating and the aperture at f/16. Applying the law of reciprocity, any equivalent combination of exposure settings can be used.

What if I don't want to use f/16 as my aperture?

It doesn't matter. From the initial base reading you can set any combination of aperture/shutter speed settings using the law of reciprocity (see page 78). For example, 1/200 at f/11, 1/400 at f/8, 1/50 at f/22, 1/25 at f/32 will all give exactly the same exposure as 1/100 at f/16. To assess the appropriate shutter speed for a change in aperture, refer to the charts on page 79.

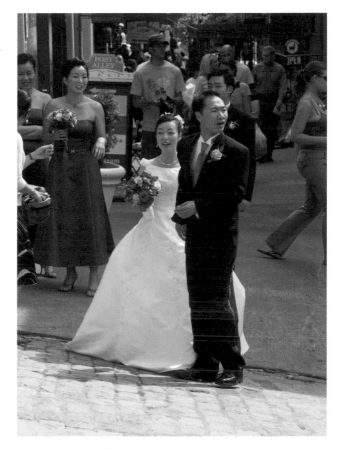

When photographing very bright subjects, such as this bride's wedding dress, use the sunny f/22 variation of the sunny f/16 rule.

Does the sunny f/16 rule work with white subjects?

The principle of the f/16 rule works when photographing bright subjects, but you may need to make a slight adjustment when, in the same conditions, your subject is white and fills a large proportion of the picture space. In such circumstances using f/16 as your base aperture can result in large areas of white burning out and a loss of visible detail. The trick is to use a variance on the sunny f/16 rule, known as the sunny f/22 rule. Both rules use the same principle, except that the base aperture set should be f/22 for the sunny f/22 rule.

How can I meter for snow?

The failings of camera light meters are never more apparent than when photographing large expanses of snow. The formula for dealing with exposing for snow is the same as that described on page 85. The camera will provide a default meter reading for a mid-tone (18 percent grey) subject. Uncompensated, the resulting image will reproduce snow as a dull grey. To get the snow looking the brilliant-white colour you expect, open the exposure (increase the exposure compensation) by around 2 stops (white is 2 stops brighter than middle tone).

When photographing snow open the exposure (increase exposure compensation) by around 2 stops from the meter reading.

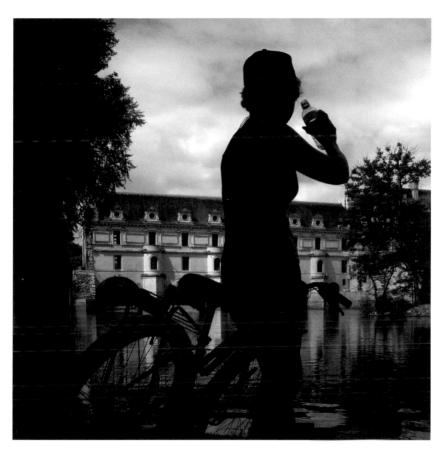

To create this silhouette of a cyclist I metered for the sky behind the subject and, using AE-Lock, locked the exposure before recomposing the image.

How do I expose for silhouettes?

To create a silhouette your subject needs to be backlit – lighting that can easily fool a meter. Switch your metering mode to manual (if your camera only has AE modes, then you'll need to use the exposure lock button). Identify an area of bright lighting behind your subject and take a meter reading from this portion of the scene. Now meter the subject using a spot meter. For a full silhouette effect the difference in stops needs to be greater than the latitude of the film or digital sensor (see page 38). Set the exposure for the highlights (the first meter reading taken in this example). When you take the shot, the underexposure for your subject will cause all detail to be lost and the subject will appear near black; creating your silhouette.

By changing the subject of the exposure you can turn a silhouette into a golden halo of light. For both of these images I exposed for the subject rather than the brighter background.

How do I create a rim of light around a subject?

Backlit subjects need not always be reproduced as silhouettes. By changing the emphasis of the exposure you can create a rim of golden light, similar to a halo effect, around your subject. The technique is similar to that for photographing silhouettes (see page 87), but rather than exposing for the highlights set your exposure to that for the subject instead.

How do I meter at night and in low light?

The process for metering in low light (including at night) is the same for any other time and occasion. You will need to take into account the effects of reciprocity law failure if using film (see page 78) and noise if using a digital camera (see page 43), as well as being aware of the issues of handling a camera when using slow shutter speeds. Another challenge you are likely to encounter is the range of your meter. All light meters operate within a finite range – a minimum and maximum level of illumination between which they can measure light. The maximum end of the scale is unlikely to be of any consequence, but in low light, and especially at night, there may be too little illumination for your meter to work effectively.

One solution to this problem is to use the simple zone system as a guide (see page 62). Using this system you can take a meter reading from a bright light source, for example, a streetlight, to gain your base reading and then measure the number of zones or stops difference between its tones and those of your subject, adjusting the exposure accordingly. For example, if the meter reading for the streetlight is 1/250 at f/4 and, using the simple zone system, you determine that your subject is seven stops darker; then your actual meter reading will be (in this example) 1/2 sec at f/4 (or an equal combination).

Another option, which can be used to extend the range of a hand-held light meter, is to remove the white dome/invercone from the meter, which absorbs roughly 80 percent of the light falling on it and extends the range of the meter by five times. Take a meter reading using the exposed metering cell and then reduce it by four-fifths.

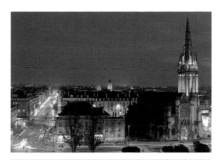

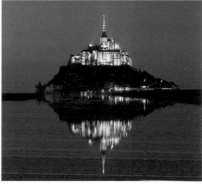

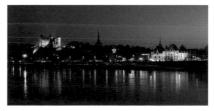

In low light you should use a tripod to combat the effects of blur from camera shake when using slow shutter speeds. If the level of light is too low for your meter try to find a bright area from which to meter and then use the simple zone system to manually calculate your exposure.

How do I meter for macro photography?

In general terms, if you are using a TTL meter then the effects of macro lenses and close-up accessories will be taken into account by the camera. When using non-automatic accessories, such as manual extension tubes, you will need to assess the absorption property of the accessory by following these steps:

Step 1
Attach your camera to a tripod and set it down, facing a solid, even-toned object, such as a wall.

Step 2
Set the focus mode to manual and focus your lens on infinity.

Step 3
Take a meter reading. This will be your base reading.

Step 4
Add the close-up accessory, such as an extension tube, bellows.

Step 5
Take a second meter reading with the close-up accessory in place. The difference between your first meter reading and the second is the absorption factor of that piece of equipment. For example, say the first meter reading is 1/250 at f/8. After adding an extension tube, the second meter reading is 1/125 at f/8. The absorption factor of this extension tube would be 1 stop and you will need to add +1-stop exposure compensation whenever the tube is used.

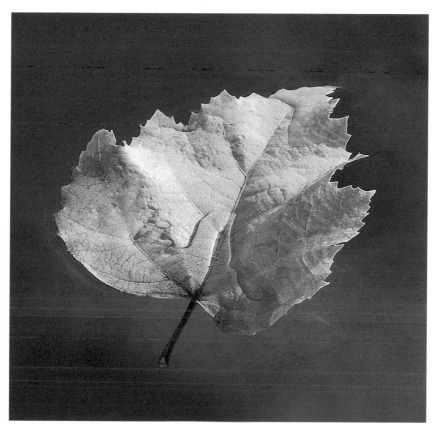

This leaf makes an ideal subject for macro photography. It is possible to pick out the smallest details on the surface.

To calculate the compensation factor of your lens, when focused at its closest focusing point, follow the same steps 1-3, then set the focus to the closest focusing distance and take a second meter reading. The difference between your first meter reading and the second is the absorption factor of the lens.

Tip

Not all macro accessories are compatible with TTL auto-exposure systems. It's always worth checking compatibility prior to purchase.

SECTION SEVEN
USING FILTERS

Filters are popular accessories in photography, whether used for artistic intent or technical necessity. There are over 200 filter types on the market today, ranging from the bizarre to the essential. This section explains how different filters affect exposure and concentrates on those that are typically used in everyday photography.

38 **FILTERS AND EXPOSURE** 94
39 **NEUTRAL DENSITY (ND) FILTERS** 95
40 **POLARISING FILTERS** 98
41 **COLOUR COMPENSATION (CC) FILTERS** 99
42 **FILTERS FOR BLACK AND WHITE** 100
43 **EXPOSURE COMPENSATION FOR FILTERS** 101

Used subtly filters can help to enhance your images. However, their effect on exposure must be understood, and, if necessary, compensated for.

Using filters with TTL meters

Different filters absorb different amounts of light, which must be taken into account when determining your exposure. TTL meters will automatically compensate for light absorption, but readings from non-TTL meters must be manually adjusted as required.

Do I need to adjust exposure settings when using filters?

It depends on whether you are using a TTL meter or non-TTL meter. TTL meters take account of any accessories fitted to the lens or between the camera body and the lens, such as filters and extension tubes. Therefore, no adjustments are necessary when using filters.

However, when using a non-TTL meter, such as a hand-held one, you will need to compensate manually for the absorbing properties of the specific filter or filters used.

Filters and light absorption

Different filters absorb different levels of light and some absorb none at all. Check with the manufacturer of each for exact calculations.

No effect on exposure. Absorbs some light requiring minimal exposure compensation. Absorbs a lot of light requiring significant exposure compensation.

Do all filters affect the level of light entering the lens?

No. Clear filters, such as UV and skylight filters, have no noticeable effect on exposure and require no compensation. The table on page 101 provides a guide to the amount of exposure compensation required for the most commonly used filters if you are using a non-TTL meter.

A skylight filter will have no effect on exposure as it absorbs none of the visible light waves.

How does a neutral density (ND) filter work?

ND filters reduce the amount of light entering the lens and subsequently reaching the film or sensor. A true ND filter will have no effect on the colour cast, hence the term neutral. They are available in different strengths, which is measured in stops.

Without the neutral density filter the level of illumination in this scene was too much to set the slow shutter speed I wanted. I added a 3 stop ND filter, which gave me a shutter speed of 1/15 sec, this was sufficient enough to create motion blur.

Why do I need a ND filter?

By reducing the level of illumination entering the lens, ND filters allow you to select slower shutter speeds than would otherwise be available. Say, for example, you are photographing a waterfall on a bright day and the slowest shutter speed available – even at the narrowest aperture setting and using the least sensitive film/sensor ISO rating – is 1/250 sec. At such a fast shutter speed it will be impossible to blur the motion of the water tumbling over the rocks. If it is an ethereal effect you want to create you would need a shutter speed of around 1/30 sec or slower. By adding a 3 stop ND filter you effectively reduce the exposure by 3 stops, allowing you to set a shutter speed of 1/30 sec.

What effect on metering does an ND filter have?

If you are using your camera's built-in TTL meter then the answer is none at all, as the meter will take account of the fact that the filter is being used. If you are using a non-TTL meter then you will need to adjust the meter reading by the strength of the filter. For example, if your non-TTL meter is giving you an exposure value (EV) of 13 when using a 3 stop ND filter, the actual EV will be 10. With a 2 stop ND filter the EV would be 11, and so on.

Filter value	Stops
.3	1
.45	1.5
.6	2
.75	2.5
.9	3

What do the numbers used for ND filters mean?

The relative strength of ND filters is typically referred to by one of the following values .3, .45, .6, .75 and .9. These values refer to the number of stops of light that the filter absorbs. The table above can be used as a handy guide.

See also

Understanding the EV chart (page 31)

What is a NDG filter?

Neutral density filters are also available in a graduated form, where half of the filter is completely clear. The purpose of a neutral density graduated (NDG) filter is to block light for only a portion of the image space. Typically, they are used in landscape photography when one section of the scene being photographed is much lighter than another, for example a bright sky compared to a shaded foreground.

A NDG filter enables you to block light from some areas of the scene while having no effect on others. They are essential tools in landscape photography.

Graduated coloured filters are also available. In addition to absorbing light, these filters will also produce a colour cast.

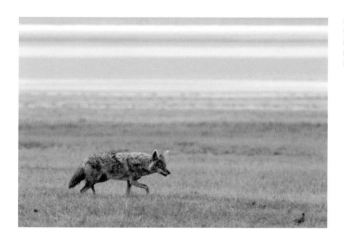

Here, I used a NDG filter to even the tones between the bright background and the lighter foreground.

How do I calculate exposure when using a NDG filter?

First, take two different meter readings: one for the brightest area of the scene and one for the darkest. Note the two readings and calculate the difference in stops between them. For example, if the light area has a meter reading of 1/500 sec at f/8 and the dark area has a reading of 1/125 sec at F/8 then the difference is 2 stops.

The difference between the two meter readings indicates the strength of the NDG filter required, in this example a .6 (2 stops) NDG filter is needed.

Once you have calculated the strength of the filter needed, set the camera's meter to manual metering mode and set the exposure for the shadow area.

Put in place the NDG filter and adjust it so that the dark section of the filter covers the bright area of the scene. If the metering mode is set to manual then the exposure settings should remain unchanged.

Meter reading from bright area of scene (e.g. 1/500 at f/11)

Meter reading from shadow area of scene (e.g. 1/60 at f/11)

Set exposure at 1/60 at f/11 adding .9 (3 stop) NDG

To calculate what strength NDG filter to use, measure the brightest area of the scene and the darkest and calculate the difference in stops.

What is a polarising filter?

Non-polariser light waves vibrate in all planes at right angles to their direction of travel. It is prevalent, for example, in light reflected from non-metallic surfaces, such as water, and in light from blue sky at 90 degrees to the sun. Our eyesight doesn't differentiate between polarised and non-polarised light. However, photographic film or digital sensors will record non-polarised light, making reflections on windows, glass and water, for example, more apparent. As their name suggests, polarising filters polarise the light entering the lens, which removes these reflections.

A polarising filter will block up to 2 stops of light.

How much exposure compensation must be applied when using polarising filters?

The filter factor of a polarising filter is x4, which means that it absorbs 2 stops of light. If you are using your camera's TTL meter then you need apply no exposure compensation, as the meter will take into account the presence of the filter. If using a non-TTL meter then you should apply +2 stops exposure compensation to the meter reading.

I have found from experience that while the +2 stops recommendation is a useful guide, the compensation value can fluctuate. I recommend metering with the polariser in position if at all possible, to ensure an accurate meter reading.

How can I meter with the polariser in place when using a hand-held meter?

If you are using a hand-held (reflected light) spot meter, then simply place the filter over the meter's lens, ensuring that no light enters via the sides. The hand-held meter will then take into account the effects of the filter on exposure. In fact, this technique can be used for any filter when using a hand-held reflected light meter.

What's the difference between linear and circular polarising filters?

In relation to exposure a linear polarising filter can cause AE systems to provide inaccurate results. When using AE metering only circular polarising filters should be used.

What's a CC filter?

Colour compensation (CC) filters, such as the 81 series of orange filters, are used to affect the colour casts caused by the different colour temperatures of light as it affects film. CC filters can also be used with digital cameras, but most models already have the White Balance (WB) setting, which manages the colour compensation process in some instances.

Do CC filters affect exposure?

A TTL meter will automatically compensate for the light-absorbing effects of CC filters. When using a non-TTL meter, use the table below as a guide to exposure compensation factors.

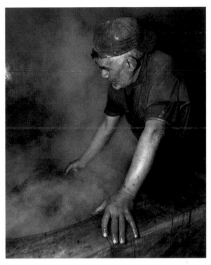

This scene was lit by a tungsten light bulb. I used an appropriate White Balance setting on my digital camera to replicate using a blue CC filter to produce a neutral white light.

Filter density	CC25	CC5	CC10	CC15	CC20	CC30	CC40	CC50
Filter colour								
Yellow	±0	±0	+$^1/_3$	+$^1/_3$	+$^1/_3$	+$^1/_3$	+$^1/_3$	+$^2/_3$
Magenta	±0	+$^1/_3$	+$^1/_3$	+$^1/_3$	+$^1/_3$	+$^2/_3$	+$^2/_3$	+$^2/_3$
Cyan	±0	+$^1/_3$	+$^1/_3$	+$^1/_3$	+$^1/_3$	+$^2/_3$	+$^2/_3$	+1, $^2/_3$
Red	±0	+$^1/_3$	+$^1/_3$	+$^1/_3$	+$^1/_3$	+$^2/_3$	+$^2/_3$	+1
Green	±0	+$^1/_3$	+$^1/_3$	+$^1/_3$	+$^1/_3$	+$^2/_3$	+$^2/_3$	+1
Blue	±0	+$^1/_3$	+$^1/_3$	+$^1/_3$	+$^2/_3$	+$^2/_3$	+1	+1, $^1/_3$

For this outdoor scene, shot mid-afternoon, I added an 81B warming filter to reduce the level of blue light and to produce a more pleasing warm orange cast.

99

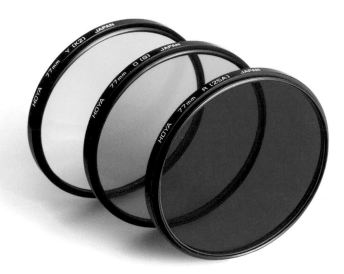

Coloured filters used in black-and-white photography will absorb light.

Why do I need a colour filter for black-and-white photography?

Coloured filters are used in black-and-white photography to manipulate tonal balance and alter levels of contrast. They manage this by absorbing the light waves. Like any filter that absorbs light, they will affect exposure.

As with all filters, the camera will compensate automatically when TTL metering is used. However, when metering using a non-TTL meter use the relevant exposure compensation factor from the table below.

Filter colour	Exposure compensation (stops)
Yellow	+1
Yellow/Green	+2
Green	+2.5
Orange	+2
Red	+3
Blue	+2

A skylight or UV filter would have helped to clarify the colours and reduce the haze in this image (facing page).

What are the exposure compensation values for commonly used filters?

Filter type	Exposure compensation (stops)
Polarising	+2 (see page 98)
Warm-up filters	
81A	$+1/3$
81B	$+1/3$
81C	$+1/3$
81D	$+2/3$
81EF	$+2/3$
Blue filters	
80A	+2
80B	$+1, 2/3$
80C	+1
Orange filters	
85	$+2/3$
85B	$+2/3$
85C	$+1/3$
Colour compensation filters	See page 99
Filters for black and white	See page 100
Neutral density filters	See page 96
UV filter	+/-0
Skylight filter	+/-0

FLASH EXPOSURE

So far, I have discussed exposure in terms of natural light. The addition of artificial (flash) light creates new challenges for the photographer, as the basic controls for standard exposures change. In flash photography, shutter speed is largely governed by flash sync speed and the speed of the emitted flash light effectively acts as the shutter speed. Instead, lens aperture and flash-to-subject distance become the key components of exposure. This section outlines some of the principal methods of calculating flash exposure.

44 **TTL FLASH METERING** 104
45 **MANUAL FLASH METERING** 106
46 **METERING FOR BOUNCED AND DIFFUSED FLASH** 108

In a studio you can control every aspect of the photographic process, including the direction, quality and colour of light.

How accurate are current TTL flash metering systems?

In general, modern flash metering systems are highly accurate as the computers within both camera and flash communicate to best-manage exposure. However, they are still governed by the generic rules of exposure.

The addition of artificial light creates new challenges for the photographer, not least of which is its effect on exposure. In these two shots, both the fox and the cougar are apparently suspended mid-air with the use of flash.

How do I know how much flash exposure compensation to apply?

Auto-flash exposure works in much the same way as standard auto-exposure. Therefore, the same rules apply for flash exposure compensation as for standard exposure compensation (see page 79).

If, for example, your subject is brilliant white, an auto-flash exposure will reproduce the subject closer to medium grey. Increasing the exposure by applying plus flash exposure compensation will produce a more natural result.

What is a Guide Number (GN)?

All flash units have a Guide Number (GN) given by the manufacturer, which refers to the maximum operating distance of the flash at a given ISO rating (often ISO 100).

How do I calculate the Guide Number (GN) for different ISO ratings?

Once you know the base GN and ISO, it isn't too difficult to calculate the GN for different ISO values. To make life easy it is useful to think in terms of f-stops (see page 72).

For example, let's say your flash has a GN of 160 for ISO 400 film. To calculate the GN for, say, an ISO 50 film, you must first calculate the difference in stops between the two ISO ratings. An ISO 50 rating is 3 stops slower than ISO 400. For the purpose of calculation, take the original GN (160) and drop the zero (effectively, divide by ten). The result is 16 or, in terms of f-stops, f/16. Now look at an f-stop scale (see page 73) and open up 3 stops from f/16 (because of the difference in ISO rating). This gives you f/5.6. Now add the zero dropped earlier (in other words, multiply by ten) and you have a figure of 56. So, your GN for an ISO rating of 50 is 56.

How do I calculate the correct flash-to-subject distance?

Unlike exposure in ambient light, flash exposure is dependent on lens aperture. Shutter speed is largely inconsequential. Once you have selected the appropriate aperture for your composition you need to assess where to position your flash unit using this formula:

$$\frac{\text{Guide Number (GN)}}{\text{f-stop (lens aperture)}} = \text{Flash shooting distance (FSD)}$$

For example, if the GN is 56 and you select an aperture of f/8 then the FSD would be seven feet (2.13 metres).

Therefore, with an aperture of f/8 the flash would need to be placed 7 feet (2.13 metres) from the subject.

Every time you change the aperture you will need to recalculate using this formula. For example, say you change the aperture from f/8 to f/11, effectively reducing the quantity of light, your new FSD would be:

$$\frac{56 \text{ (GN)}}{11 \text{ (f-stop)}} = 5 \text{ feet (1.52 meters) (FSD)}$$

Calculating flash-to-subject distance

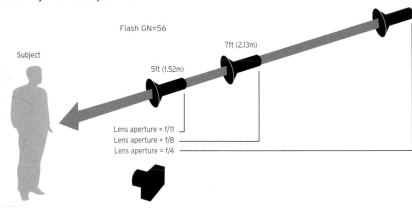

Flash GN=56

Subject

14ft (4.3m)

7ft (2.13m)

5ft (1.52m)

Lens aperture = f/11
Lens aperture = f/8
Lens aperture = f/4

What happens if the flash distance is fixed?

Simple, you calculate the required aperture by revising the formula to:

$$\frac{\text{Guide Number (GN)}}{\text{Flash-to-subject distance (FSD)}} = \text{F-stop (lens aperture)}$$

For example, if the flash unit is 14 feet (4.3 metres) from the subject and the GN is 56 then the appropriate f-stop would be f/4, because:

$$\frac{56 \text{ (GN)}}{14 \text{ (FSD)}} = 4 \text{ (f-stop)}$$

How do I get an even exposure that includes a well-lit background?

The illumination of the background will depend on two things: the distance of the background and the reflectivity of it.

Light intensity follows the inverse square law: double the distance from the light source and the illumination will be one quarter. At three times the distance the illumination will be one-ninth that of the subject.

Reflectivity is more problematic. Lighter backgrounds, as you would expect, reflect more light than darker surfaces but surface finish also has a bearing as more light is reflected from glossy surfaces than from satin or matt ones. We can avoid some of the consequent problem using bounced flash techniques (see page 108).

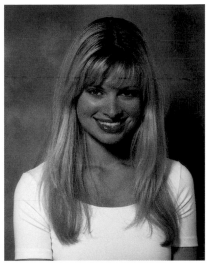

Original image

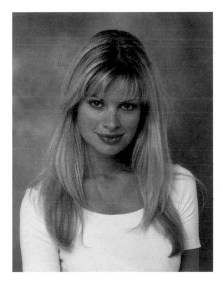

In this example the background is about twice the camera-to-subject (and flash-to-subject) distance. In the original image (top) the flashgun was camera mounted and shot directly at the subject. There are harsh shadows on the face, and the background is poorly lit. In the second image (bottom) shot the flash is still directed at the subject, but a large diffuser and reflector were used to even out the illumination and fill the shadows. Exposure calculations are still based on camera/flash-to-subject distance.

With diffuser

This image was taken using flash bounced off a white ceiling, which involved calculating both the total flash-to-subject distance as well as compensating for the absorption properties of the ceiling and light scatter.

How can I calculate exposure when using bounced flash?

Use the same formula as for a fixed flash shooting distance (see page 106), add the flash-to-reflector distance and the reflector-to-subject distance together to give a total flash distance.

You may need to apply around +1 stop exposure compensation to allow for absorption.

Calculating exposure for a bounced flash

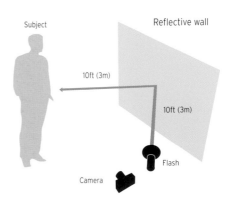

Subject

Reflective wall

10ft (3m)

10ft (3m)

Flash

Camera

I used a diffused flash (a soft box) for this studio portrait. Before setting the exposure I calculated the absorption properties using the steps described.

How do I expose for diffused flash?

A diffuser helps to turn a flash unit from a point (hard) light source into an omni-directional (soft) one. Adding a diffuser won't change flash-to-subject distance, but it will affect the level of illumination due to absorption. When calculating flash exposure manually you will need to compensate for this absorption by following these steps:

Step 1
Compose the picture with the camera mounted on a tripod and the flash attached.

Step 2
Take a picture with no diffuser in place, using the manual flash calculations. This will form your base aperture.

Step 3
Without moving the camera or flash unit, add the diffuser. Then shoot several frames at exposures above and below the base aperture, increasing aperture setting by 1 stop each time, noting the aperture settings for each frame.

Step 4
Once the images are processed, compare them to ascertain the best-exposed image, refer to your notes to find the aperture used for that frame.

Step 5
Using the f-stop scale (see page 73), calculate the difference in stops between this aperture setting and the base setting. This figure is the absorption value of the diffuser.

Can I use a non-digital flash unit with a digital camera?

The characteristics of digital sensors differ greatly to that of film, and this poses a new series of problems when using flash in digital photography. Ideally, you should purchase a dedicated digital flash unit to use with your digital camera. You can, however, use a film-based flash unit, although you will need to run some calibration tests to see whether exposure is affected. As the difference is media-based and therefore consistent, you will be able to apply any necessary compensation consistently from shot to shot.

THE DIGITAL DARKROOM

There has been (and continues to be) much debate about the role of the computer in digital photography. Many see the digital enhancement of images as a form of manipulation that goes against the photographic grain. Others see it as nothing more than an up-to-date method of image-processing.

The reality is somewhere in the middle, and to my mind there is a definite distinction between image-enhancement and digital manipulation. Photographic film and digital sensors are incapable of recording light in the exact way that we see it. Therefore, in order for a scene to appear in a photograph just as we perceived it at the time of capture, it is necessary to make adjustments during printing. This is image-processing (enhancement) and a natural part of the photographic process, whether that work is carried out in a traditional darkroom or with the aid of a computer and software.

However, such is the power of digital intervention – if I can use that term to include both enhancement and manipulation – that we can now create imagery that could never be seen in the real world. This is where digital intervention becomes morally and artistically questionable.

In this section I'll demonstrate how digital techniques may be used to (largely) recreate conventional darkroom enhancement, and the ways in which digital technology can help us retrospectively duplicate in-camera effects to help our photographs achieve the vision we had for them when we first composed them in the viewfinder.

I've used Adobe's Photoshop to illustrate the techniques here as I believe it's the de facto standard amongst professionals and serious amateurs, and is widely available. However, virtually everything in this section can be undertaken using most image-editing applications.

47 **USING LEVELS AND CURVES** 112
48 **SELECTIVE EXPOSURE TECHNIQUES** 118
49 **ENHANCING DEPTH OF FIELD AND MOTION** 128
50 **COLOUR COMPENSATION** 134

Cameras, films and digital sensors all have limitations that stop them from seeing and recording the world as we see it with our own eyes. Image processing helps us to overcome these limitations and create images that more accurately match the scene as we perceived it at the point of capture.

What is a pixel?

The term pixel means 'picture' (pix) 'element' (el). Every pixel has a value, ranging from 0 to 255, and each value represents a shade of grey, ranging from black (0) to white (255). So if an image has a resolution of 12.5 million pixels, it is constructed from 12.5 million tiny squares of varying values. In many ways pixels are the photographic equivalent of painting by numbers. When all the pixels are positioned together they form an image and the quality of that image, is in part dependent on the physical size and quality of each pixel.

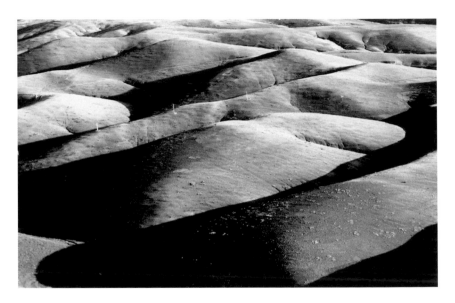

See also

Histograms and the highlights screen (page 34)

What does the Levels tool do?

With some exceptions (such as silhouettes and high-key images), a well-exposed photograph is considered to be one that has a full tonal range, across the digital histogram. The Levels tool in Adobe Photoshop enables you to adjust the tonal range of a digital image by re-mapping pixel values so that the darkest pixels equate to black and the brightest pixels to white. The result of this will be an increase in contrast.

What are the elements of the Levels tool?

Channels

The drop-down Channel box allows you to select individual or all (RGB) colour channels for adjustment. This allows you to re-map pixels of a single colour only or all colours simultaneously.

Preview

Selecting the Preview box will cause adjustments to pixel values to show in real time on the screen.

Black adjuster arrow

The black adjuster arrow re-maps pixels to black (value 0).

White adjuster arrow

The white adjuster arrow re-maps pixels to white (value 255).

Grey adjuster arrow

The grey adjuster arrow re maps pixels to mid-tone grey.

Black eye-dropper

The black eye-dropper allows you to select a precise value (tone) as the black point. All pixels with a value below or equal to the selected tone will be re-mapped as black (value 0).

White eye-dropper

The white eye-dropper allows you to select a precise value (tone) as the white point. All pixels with a value above or equal to the selected tone will be re-mapped as white (value 255).

Grey eye-dropper

The grey eye-dropper allows you to select the mid-tone point. All pixels are then adjusted accordingly.

How do I use the Levels tool to increase contrast?

Before

Step 1
Having opened your image on screen, bring up the Levels dialog box by selecting Image>Adjustments>Levels from the drop-down menu.

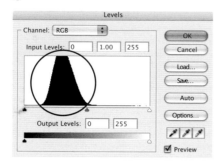

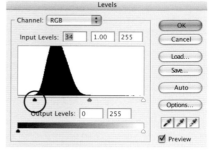

Step 2
You will see a histogram in the main window of the Levels dialog box.

Step 3
Using the cursor, select the black adjuster arrow and drag it to the right until you reach the point where the histogram shows the darkest value of the current image. If the Preview box is checked, you will notice that the image on screen darkens.

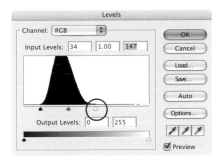 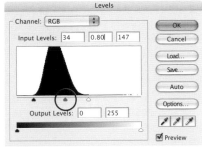

Step 4
Next, drag the white adjuster arrow to the left until the histogram shows the brightest value of the current image. If the Preview box is checked, you will notice that the image on screen brightens.

Step 5
To lighten or darken the overall image, without greatly affecting the highlights and shadows, drag the grey adjuster arrow, either left (to lighten) or right (to darken). Again, you will notice the effect if the Preview box is checked.

After

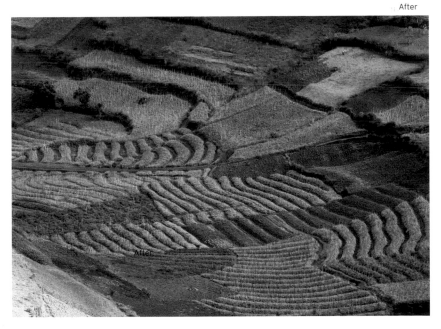

Step 6
When you have completed all Levels adjustments, save the image using File>Save (or File>Save As to save the image with a different file name).

What is the Curves tool?

In its simplest form the Curves tool does much the same task as the Levels tool. It enables you to re-map the white and black points, but without the aid of the histogram. At first glance the Curves tool appears far more complicated to use than Levels, and for basic adjustments of the shadows and highlights, Levels is perhaps the better option. However, Curves is a far more powerful tool than Levels as it also enables you to control the overall contrast.

Before

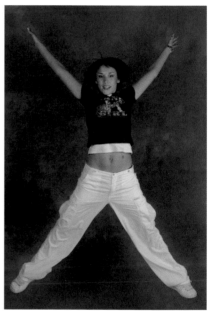
After

In this example, I anchored the curve close to the highlights in order to preserve the existing values. I then manipulated the curve, using additional anchor points to create a steep curve that will alter contrast levels, to adjust the tonal balance in the shadow and mid-range tones.

Tip

When you adjust contrast using Curves you affect the saturation as well as the tonal balance. To avoid Curves adjustments affecting the image colour open the Fade Curves option in the Edit menu. In the Mode drop-down menu select Luminosity and click OK. This enables Curves to affect only the luminance and leaves unchanged saturation.

How can I correct shadow and highlight detail using Curves?

At its default setting the Curves dialog box appears like this (above). Unlike Levels, in Curves the levels relationship between pixels is plotted as a graph. The top right corner of the graph represents white (255) and the bottom left corner represents black (0). By dragging the ends of the curve in, as you would in Levels, you are able to re-map the white and black points. With the preview box ticked the changes made by the Curves adjustments will show on the image on the desktop.

How can I control lightness and contrast using Curves?

As well as re-mapping the white and black points Curves also allows you to adjust lightness and contrast. Dragging the curve up towards the top left corner will lighten the image, while dragging it to the bottom right hand corner will darken the image. The steepness of the curve determines contrast. A steep curve has increased contrast while a flatter curve has reduced contrast.

Why use Curves and not the Lightness/Contrast tool?

The advantage of Curves is that it preserves the highlight and shadow detail in an image. When the Lightness/Contrast tool is used it is applied across the whole image, which can result in clipping. Curves produces a more accurate result without degrading image quality.

Can I get more accurate results using Curves?

By placing Curves points along the line you can anchor areas of the image, such as the highlights, so that any Curves adjustments you make affect mainly those pixels beyond the anchor point.

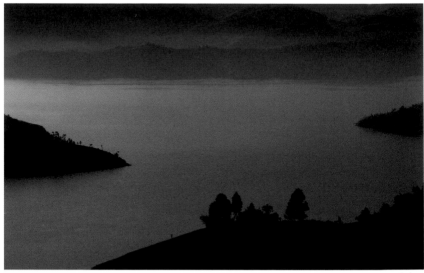

Before

Is there a quick and simple method of dealing with underexposure?

Step 1

You can improve the exposure of underexposed images using Layers in Photoshop. First, open an underexposed image (File>Open), and then open the Layers window (Window>Layers). You will see one current layer named Background.

Step 2

Create a duplicate layer (Layer>Duplicate layer) and name it Duplicate. You will notice a new layer appear called Duplicate in the layers window box. Highlight the duplicate layer, and in the layers window box change the mode to Screen. You will notice the image lighten.

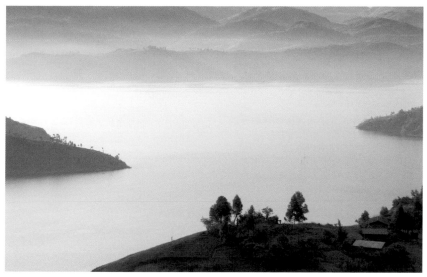

After

Step 3
Repeat Step 2 until the image is close to the best exposure.

Step 4
To fine-tune exposure using this technique, alter the opacity of the top layer in the layers window box. You will notice the image lighten. Repeat this step until the image is close to the best exposure.

How can I dodge and burn like the pros?

Dodging (lightening) and burning (darkening) are age-old darkroom techniques that can be applied digitally. This method of applying dodge and burn is used by professional image-editors.

Dodge Burn

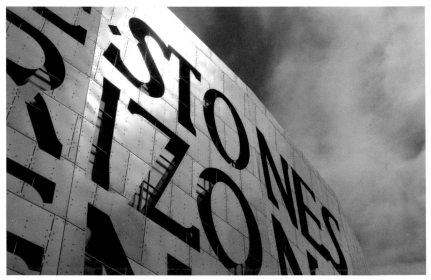

Before

Step 1

Open the image (File>Open) display and the Layers dialogue box (select Windows>Layers to make visible). Create a new layer (Layers>New), and call it Dodge and Burn. With this layer selected, change the Blend Mode in the pull-down menu from Normal to Soft Light.

Step 2

Set your foreground colour to white, choose a Brush tool and set Opacity to around 30 percent. This will soften the changes you make for a smoother result. Now apply the dodge tool to the areas of the image you want to lighten.

Step 3

Change the foreground colour to black and apply the Burn tool to the areas of the image you want to darken.

After

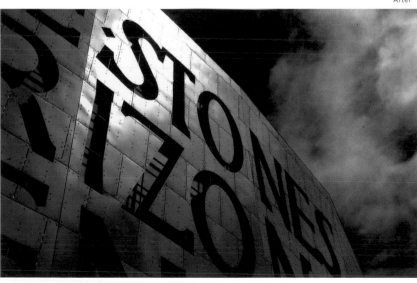

What is the Shadow/Highlight Tool?

There are many situations where the brightness levels between a subject and its surroundings are such that a single exposure cannot record both elements effectively. Some are obvious. Backlighting, for example, when the sun behind the subject, is one. We could, in some circumstances, achieve good exposure using fill-in flash techniques. At other times, or where such remediation will not be effective, we need to consider alternatives. It may be that we have a wide brightness range or a predominance of shadow areas that cannot be 'lifted' by flash without compromising other elements in the image.

We can resort to the Levels and Curves tools to make some modifications but we have another option; a tool specifically designed for the purpose. The Shadow/Highlight tool can let us modify the brightness and contrast in an image with much more control. The Shadow/Highlight tool can be applied to an image using default settings with a high degree of success and provides additional controls and adjustments to cater for those images that need more subtle corrective measures.

Before

After

Too distant to use fill-in flash, this scene could not be recomposed to avoid the bright sky. Application of the Highlight/Shadow tool using only default settings immediately reduces the difference in brightness levels and produces an acceptable image.

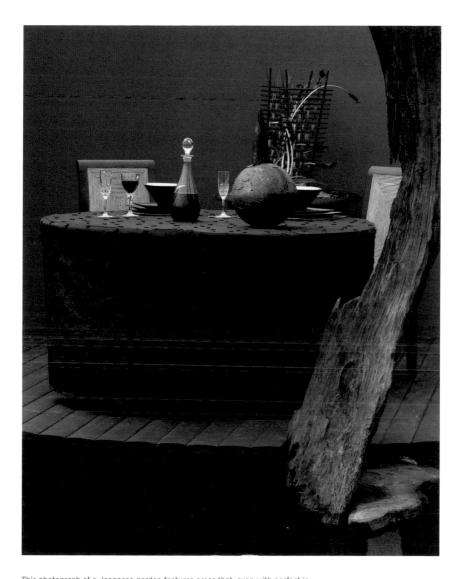

This photograph of a Japanese garden features areas that, even with perfect in-camera exposure, still fail to deliver on shadow detail. Adjusting the levels will produce a modest improvement, but some regions, such as the table cloth, will still lack detail. The Highlight/Shadow tool will further improve, and detail, the image in a more controlled and subtle way than in the example on the facing page.

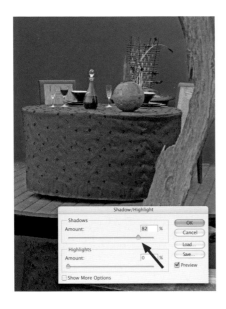 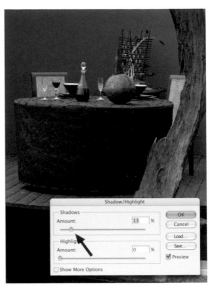

What are the Highlight and Shadow sliders?

The basic controls for the Highlight/Shadow tool are the Highlight and Shadow sliders. These adjust the light and dark (or shadow) areas in the scene respectively. The Highlight slider will darken the highlight parts of the image as it is moved progressively to the left. The default settings are 50% for the Shadow amount and 0% for the Highlights amount.

As you make adjustments you will see your changes represented in the image, but unlike some other Photoshop tools you will need to wait a few seconds to see these adjustments on screen. Resist the urge to move the sliders progressively more when you don't see any immediate changes!

As well as dragging the slider you can also enter a numeric value to make the adjustments more precise. That's not so important in most cases, but for some the ability to adjust in single figures, or even decimals, can be crucial.

What other controls do the Highlight/Shadow sliders have?

Clicking on the Show More Options check box will reveal the additional controls for the Highlight/Shadow tool. For each of the two Amount sliders we now have four additional control options: Tonal Width, Radius, Color Correction and Midtone Contrast.

Tonal Width

The Tonal Width slider allows us to control the range of pixel values that we include in the adjustment. Set a low value here for Shadows and only the darkest pixels will be included in any adjustment (this is useful for lightening the darkest, deepest shadow areas without altering intermediate shadows). Drag each of the sliders to the right to increase the tonal width and consequently the range of pixels that will be included in the adjustment.

Radius

Use the Radius slider to adjust the number of neighbouring pixels that will be affected by any adjustment. As this control is not dependent on the luminosity of the pixels it can be used to soften any effect of the Highlight/Shadow tool to give a subtle and natural look.

Color Correction

The Color Correction slider determines how vivid (or not) the colour is in the corrected region. This slider can be used to alter the colour saturation. Adjustments often exacerbate random colour or regions of colour unduly.

Midtone Contrast

The final setting, Midtone Contrast, gives you fine control of the image contrast in the areas that have been adjusted by the Highlight/Shadow command.

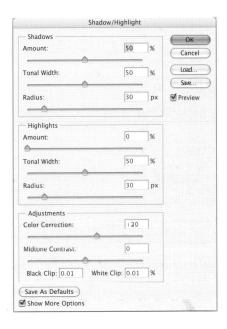

125

How do I use the Highlight/Shadow tool to improve the exposure across a photograph?

Step 1
Select Image>Adjustments>Highlight/Shadow. You'll see the effect of the tool immediately on the photograph. With the default (maximum) settings the result will usually be extreme and unrealistic.

Step 2
Move the Highlight slider to the left to reduce the impact of this component of the tool.

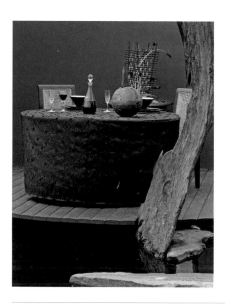

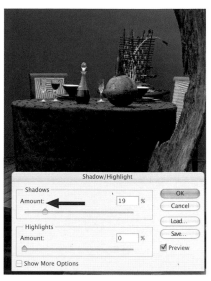

Does the Shadow/Highlight tool mean that I don't have to be concerned with backlight compensation in-camera?

No, this is essentially a corrective tool. You should use your skill and knowledge of exposure to achieve the best results in camera, but Shadow/Highlight can rescue a shot that would otherwise be lost, or can improve the balance between the shadow and highlight elements in a scene.

Is there any image degradation when using the Shadow/Highlight tool?

Unfortunately, yes. As we brighten dark areas and attempt to squeeze more image information from bright areas we also exacerbate image noise (see page 43). You could liken this to the situation where, with conventional film, you push-process to shoot at very low light levels. The results, as with film, can be grainy and washed out.

Step 3

Click on the Show More Options button to reveal further controls. Adjust the Tonal Width sliders first, and then the Radius sliders to soften the appearance of the adjustments.

Step 4

Use the Color Correction slider and, if necessary, the Midtone Contrast control to give the corrected parts of the image a colour saturation that matches the unaffected areas and a similar contrast.

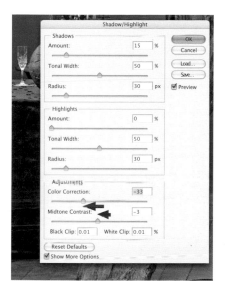

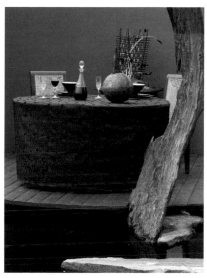

Can the Shadow/Highlight tool work with all shots that have extreme brightness ranges?

This is no magic tool, but if there is detail in your photograph that is notionally concealed, the Shadow/Highlight command can generally accentuate it.

Tip

The Shadow/Highlight tool is useful in extending the effective range of fill-in flash. Fill-in flash can't provide sufficient light to illuminate a dark or distant background without washing out the foreground subjects. By exposing for the subject and then using the Shadow/Highlight tool you'll get a much more even result.

How do I modify the depth of field in this photograph?

Unlike some other image-editing tools there's no quick fix command that lets us instantly modify the depth of field; instead you need to use a simple tool – a blurring filter – and an awareness of how depth of field affects an image. Your aim is to emulate the effect of a lens with a wide aperture. Such a lens ensures that the subject remains in sharp focus at all times, but those parts of the scene that are further away from the subject, both beyond and in front, become progressively blurred with distance.

The Gaussian Blur tool is exceptional in that it allows us to control the amount of blurring introduced, from an imperceptible amount through to an extreme that can render the image virtually unrecognisable. By selectively applying a progressively stronger Gaussian Blur to areas of the photograph further away from the subject we will be able to produce a seamless reduction in the depth of field.

With a modest setting, the Gaussian Blur filter takes the edge off the sharpness in an image but by moving the slider to the right the image rapidly loses definition.

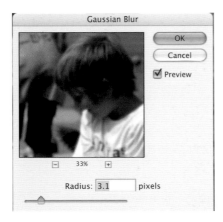
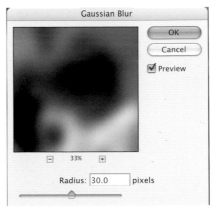

Before

Step 1

This candid 'grab' shot was taken using a 100mm telephoto lens. The camera, set to auto, produced an effective exposure, but has also, by virtue of the high light levels, given us more depth of field than I would have liked. To concentrate attention on the two boys and the pigeons we need to reduce the prominence of the background and foreground.

See also

Aperture and depth of field (page 76)

Step 2

Use the Lasso tool to select an area of approximately equidistant parts of the scene in the extreme background (indicated here by the red line). Apply a modest Gaussian Blur. Use the Feather option in the toolbar to give soft outline to our blurred area.

Step 3

Extend the selection to include more of the intermediate area between the subject and the first selection and apply the Gaussian Blur filter again. This will also further blur the area included in the original selection.

Step 4

Extend the selection again to include the area nearest to the subject. This time be sure to also include those areas between the camera and the subject. Apply the Gaussian Blur filter for a final time.

After

Step 5

The finished image. Compare this with the original and you'll see how we have modified depth of field to make the subjects more prominent.

What's the Motion Blur filter?

If you've taken a look at the blur filter selection provided in Photoshop you may have noticed the Motion Blur filter. This filter is ideal for enhancing motion effects in your photographs.

If you have ever taken a shot of a moving object, for example a racing car, and you have panned the camera to keep the car itself sharp, you may have been disappointed with the result because if the actual exposure was short, the sense of motion would have been negligible. In fact, rather than motion, it may simply have looked blurred!

The Motion Blur filter allows you to enhance the amount of motion blurring in these cases. To use it simply select the area you wish to blur and set a modest feather amount so that any blur merges seamlessly. In the Motion Blur dialog, set the angle of the blur to match that of the direction of motion.

Can I digitally increase the depth of field?

You may need to increase the depth of field if low light levels force you to shoot with very wide apertures. At the widest aperture, although most of our subject may be in focus some parts may not.

In such instances, this can be remedied by using a selection tool (such as the Lasso) to select your subject and then apply a Sharpening filter. The Unsharp Mask is the best tool to use here because of the greater level of control it offers, but it can be more problematic to master; Sharpen or Sharpen More should give you sufficient sharpening to make the subject more prominent.

Tip

Sharpening a photograph is not the same as improving the focus. You can't digitally restore details that were not present in the original photograph, but you can make it appear to be sharper. Bear this in mind when applying sharpening tools and never over-sharpen your images.

How much Gaussian Blur should I apply?

Aim for a modest increment for each stage. Gaussian Blur amounts are measured in pixels and are therefore dependent on the resolution of the image: the more megapixels in your image, the greater the amount you will need to apply to achieve a similar effect. Use a figure of between ten and 20 pixels as a starting point, but observe the effects at each stage. It's better to build up blurring gradually than to be too heavy handed.

How much Feathering should I apply?

Start with an amount of around ten pixels to begin with. Once you have applied the blurring examine the image to see whether you have a smooth transition between the original and blurred sections. If not, repeat with a larger feathering amount.

When you are selecting the area around your subject use a much smaller feathering amount (one or two pixels). This will prevent the blurring blending with the subject to produce an indistinct boundary.

Can you overdo depth of field modification?

Yes! Too much sharpening leads to digital artefacts (noise) appearing. Apply too much blurring at each stage when reducing the depth of field and you can achieve an unrealistic effect where the subject appears too detached from its surroundings. Remember you are aiming to produce the same results as you might were you to produce them in-camera.

Taken with the lens aperture wide open, depth of field was so limited in this shot that only part of the subject was critically sharp. Without a tripod or other means of support that would enable longer exposures at smaller apertures this was the best result that could be achieved.

The Unsharp Mask filter was applied to the subject to enhance the perceived sharpness. When viewing this image we are not distracted by the lack of sharpness.

Applying too much sharpening leads to the appearance of digital artefacts (noise) and will compromise image quality. If a subject does not respond to a modest amount of sharpening don't be driven to further sharpen.

Can I digitally apply colour casts?

Image-editing applications are adept at colour manipulations, and colour casts can often be removed with a single keystroke. However, corrections like this tend to be somewhat idealised, rather like the auto colour correction facilities offered by processing labs, they have a tendency to neutralise predominant colours. This is fine for many photographic applications, but not when a colour dominance is key to the photograph. A sunset for example can end up looking washed out.

Sometimes though, you may want to enhance an existing colour cast, or even introduce one. Thanks to a range of what image-editing applications describe as 'photographic filters', you have the option of doing just this.

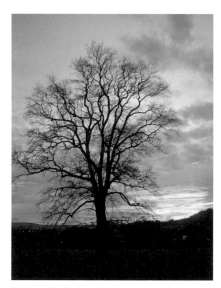

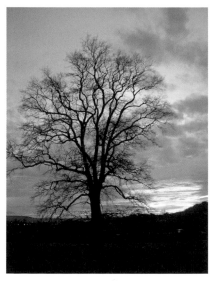

Commercial processing machines don't realise that strong colour casts can be important to some images, and tend to 'correct' or neutralise any bias. The result can be lacklustre colour as is the case in this image.

If the automatic correction had been overridden by the machine operator, the sunset would have featured vibrant reds and blues.

How do I apply a Photo Filter?

You'll find Photo Filters in the Image>Adjustments submenu. Select it and you'll open a dialog box. A pull-down menu will then allow you to select a filter type.

You'll also find that there's a percentage slider, which comes in useful for toning down the effect of those filters that you consider too powerful when used at full strength. In practice you will probably find that most of the filters work best (that is, are most realistic) when used at strengths of between ten and 15 percent.

Direct from a digital camera, this image lacks the warmth you might expect from sunset shots. The camera's White Balance has removed the bias towards warm colouration.

Digitally applying a warming photographic filter restores the warmth, giving the church a ruddy glow, and the sky, rather than appearing neutral grey, is now a warm grey.

Can I digitally emulate the effect of colour filters on black-and-white film?

Start with a black-and-white digital image and there's no easy way to replicate the effect of coloured filters used over the lens. For example, you can't apply a red filter to create dark skies with bright white clouds, because there is no colour information present in a black-and-white image to interact with the filter.

However, you can digitally emulate the effect of coloured filters on black-and-white film. It's a simple technique that can be achieved by following these simple steps.

Step 1
Start with a colour image. This shot of the Campanile in Venice is a good example because it contains a bright blue sky, red brickwork and some green foliage

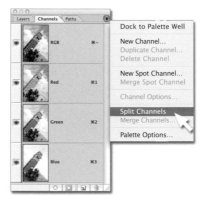

Step 2
Select the Channels palette. You can make this visible by selecting the tab on the Layers palette (usually) or by selecting Channels from the Window menu. This gives us intriguing thumbnails marked red, green and blue.

Step 3
Click on the small arrowhead to the top right of the Channels palette to reveal the submenu and select Split Channels. This will split the original colour image into three monochrome images, each equivalent to shooting the scene through a red, green or blue filter.

The red channel provides the same effect as if you had shot a scene through a red filter on black-and-white film. Blue sky is dark, but the red brickwork is light.

Had you shot through a blue filter, you would have got a result like this. Blue sky and clouds are both white, yet the brickwork is much darker. As with the Red Channel, green foliage is, in brightness terms, little different from in the colour image.

It's unlikely you would have shot a photograph through a green filter, but had you done so, this would be the result. Foliage is lighter but, generally, contrast is lower than in the Blue or Red channel shots, leading to a less dramatic shot.

Can I vary the 'filter effect' of splitting into separate channels?

Yes, you can. You could do this by adjusting the colour saturation and hue prior to splitting. Use the Hue/Saturation command and adjust the hue of the sky to cyan and you'll get a much less pronounced darkening in the Red channel.

Are Red, Green and Blue channels the only options?

No. If you convert your photograph's Image Mode from RGB Color to CMYK Color (using Image>Mode) you can split the image into cyan, magenta, yellow and black channels.

18 percent grey 30, 54
 see also mid-toned subjects
35mm cameras 63

absorption of light 94
Adams, Ansel 62
Adobe Photoshop 111-37
AE metering *see* auto exposure metering
angle of incidence 59
aperture *see* lens aperture
aperture-priority auto exposure 29
auto bracketing 56
auto exposure (AE) metering 48, 65
 see also meters/metering
average metering 27, 49, 60

background illumination 107
backlighting 87-8, 122
black-and-white photography 100, 136-7
blur effects 75, 128-32
bounced flash 108
bracketing 56
bright subjects/conditions 52, 84-5
brightness range 66-9
burning 120-1

calibration of meters 33
cameras *see* digital cameras
CC *see* colour compensation
centre-weighted metering 27, 49, 60
circular polarising filters 98
clear filters 94
close-up photography 90-1
colour
 compensation 16-17, 99, 134-7
 digital enhancement 113, 125
 of light 14-15
 meter reading effect 54
colour casts 16-17, 134
colour compensation (CC) filters 99
coloured filters 96, 100, 136-7
compensation
 colour 16-17, 99, 134-7
 filters 98-9, 101
 flash exposure 105
 metering without mid-tones 58
 polarising filters 98
 tonality 55
contrast 38, 114-15, 117, 125
Curves tool 116-17

dark-toned subjects 52, 55
depth of field 76-7, 128-33
diffusers 13, 107, 109
digital cameras
 bracketing 56
 flash units 109
 ISO ratings 41
 law of reciprocity 80
 sensors 37-45, 68, 71
 White Balance 18
 zone system 63
digital enhancements 111-37
digital histograms 34-5
digital noise 43-4
digital sensors 37-45, 68, 71
direction of light 12
dodging 120-1
duration of exposure 74
dynamic range of sensors 39

EV *see* exposure value
exposure compensation *see* compensation
exposure modes 29
exposure value (EV) 31, 32

f-stops 72-3, 76-7, 84-5
 see also stops
faithful exposure 7, 81
Feathering tool 132
fill-in flash 122, 127
film 37-45, 68, 71, 79-80
film grain 42, 44
filters 16-17, 92-102, 128-32, 135-7
flash photography 25, 103-9
flash-to-subject distance (FSD) 106-7
freezing motion 75
front lighting 12
FSD *see* flash-to-subject distance
Fujichrome films 80

Gaussian Blur filter 128-32
GN *see* Guide Number
graduated filters 96-7
grain 42, 44
grey cards 30, 55
Guide Number (GN) 105, 106

hand as grey card 30
hand-held light meters 22, 24-5, 89, 98
highlights 34, 117, 122-7
histograms 34-5

image-processing 111-37
incident light meters 23
inverse square law 107
ISO-E ratings 40-1
ISO ratings 40-1, 45, 80, 105

Kelvin temperature 14
Kodak films 79

latitude 38-9, 68
law of reciprocity 31, 78-80, 84-5
lens aperture 32, 71-2, 76-7, 84-5, 106
Levels tool 112-15
light 11-19
 absorption 94
 difficult conditions 83-91
 intensity 107
 metered/actual subject 57
light meters 22-5, 52-5, 89, 98
 see also meters/metering
lightness control 52, 55, 117
linear polarising filters 98
low light metering 89

macro photography 90-1
manual exposure 29
manual flash metering 106-7
meters/metering 21-34
 calibration 33
 flash exposure 104-9
 macro photography 90-1
 modes 26-8, 48-51, 65
 ND filter effects 96
 night/low light 89
 off-centre subjects 60-1
 polarising filters 98
 readings 47-69, 97
 selecting an area 57
 snow 86
Midtone Contrast control 125
mid-toned subjects 52, 54, 57, 58
 see also 18 percent grey standard
motion 75, 128-33
multi-segment metering 26, 48

neutral density (ND) filters 95-7
neutral density graduated (NDG) filters
 96-7
night metering 89
noise 43-4

off-centre subjects 60-1
overexposure 52, 55, 81

Photo Filter 135
Photoshop (Adobe) 111-37
pixels 34, 112
polarising filters 98
programmed auto exposure 29
pushing/pulling film 45

quality of light 13

Radius slider 125
reciprocity 31, 78-80, 84-5
Red, Green and Blue (RGB) 113, 137
reflected light meters 23
reflectivity 107
RGB see Red, Green and Blue
rim-lighting effects 88

SBR see subject brightness range
selective exposure techniques 118-27
sensors 37-45, 68, 71
shadow control 117, 122-7
sharpening images 132, 133
shutter-priority auto exposure 29
shutter speed 32, 71, 73-5, 84-5, 103
silhouettes 6, 81, 87
simple zone system 62-5, 67, 89
skylight filters 94, 100-1
snow photography 86
spot metering 24, 28, 50-1, 61
'stopping down' 77
stops 38-9, 41, 45, 72-3
 see also f-stops
subject brightness range (SBR) 66-9
sunny f/16 rule 84-5

temperature of light 14-15
through-the-lens (TTL) meters
 22-5, 94, 104-5
Tonal Width slider 125
tonality 19, 25, 54, 55, 125
TTL meters see through-the-lens meters

underexposure 52, 55, 81, 118-19
up-rating film 45

White Balance (WB) 18
white subjects 85, 105
zone system 62-5, 67, 89

ACKNOWLEDGEMENTS

I would like to thank the following people who have helped to produce this book:

Caroline Walmsley, Renée Last and Brian Morris at AVA Publishing; David Crow; Peter Cope; Richard Williams and Indexing Specialists (UK) Ltd.; Steve Aves at Bowens Lighting; Jane Nicholson at Intro2020; Fraser Lyness at Natural Photographic and Rod Wynne-Powell at Solutions Photographic.

Finally, thanks to my family, who always put up with the most.